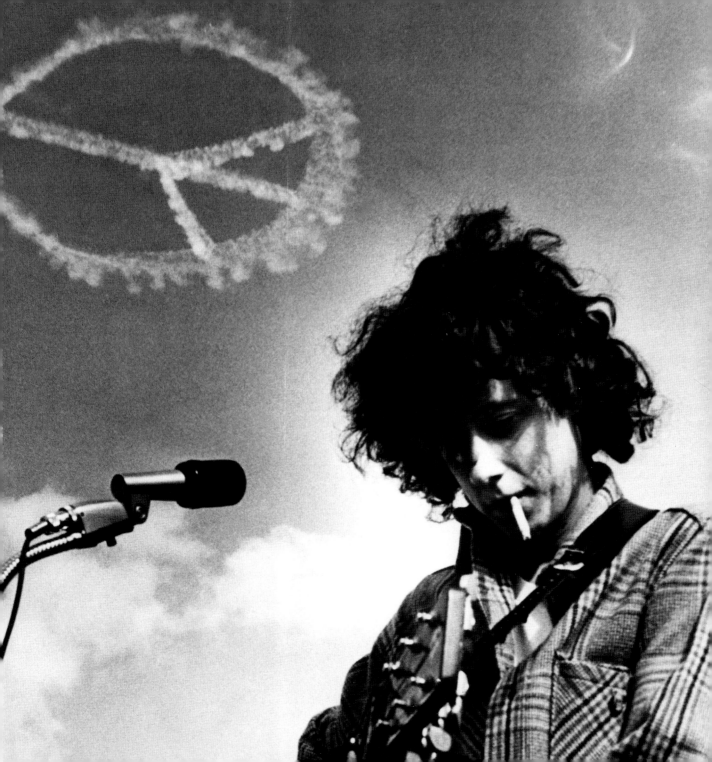

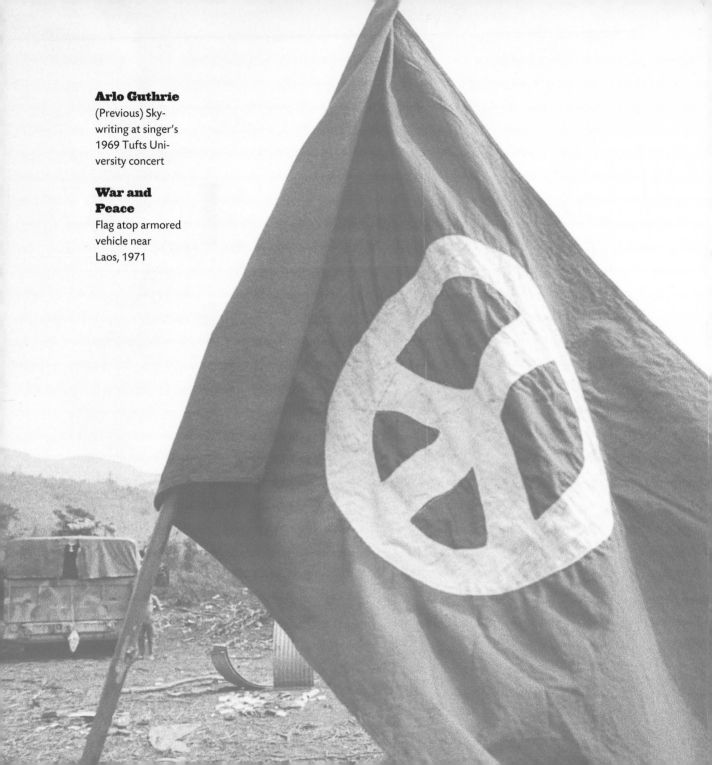

Arlo Guthrie
(Previous) Sky-
writing at singer's
1969 Tufts Uni-
versity concert

**War and
Peace**
Flag atop armored
vehicle near
Laos, 1971

PEACE

The Biography of a Symbol

Ken Kolsbun

with **Mike Sweeney**

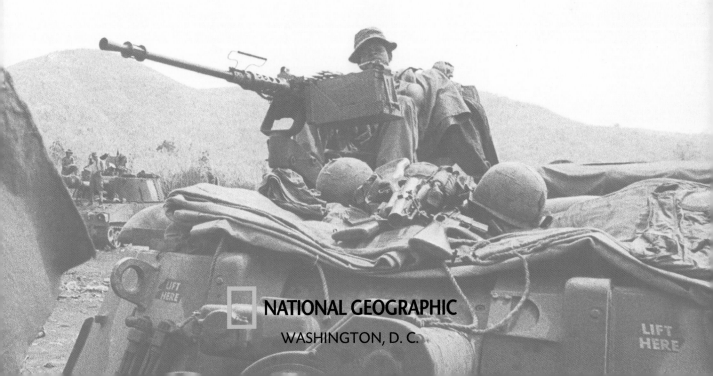

NATIONAL GEOGRAPHIC

WASHINGTON, D. C.

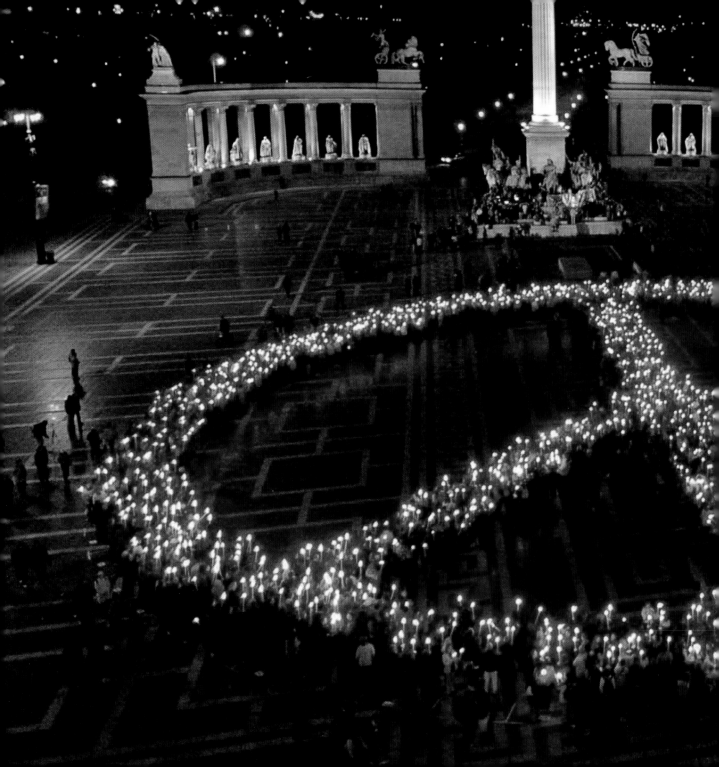

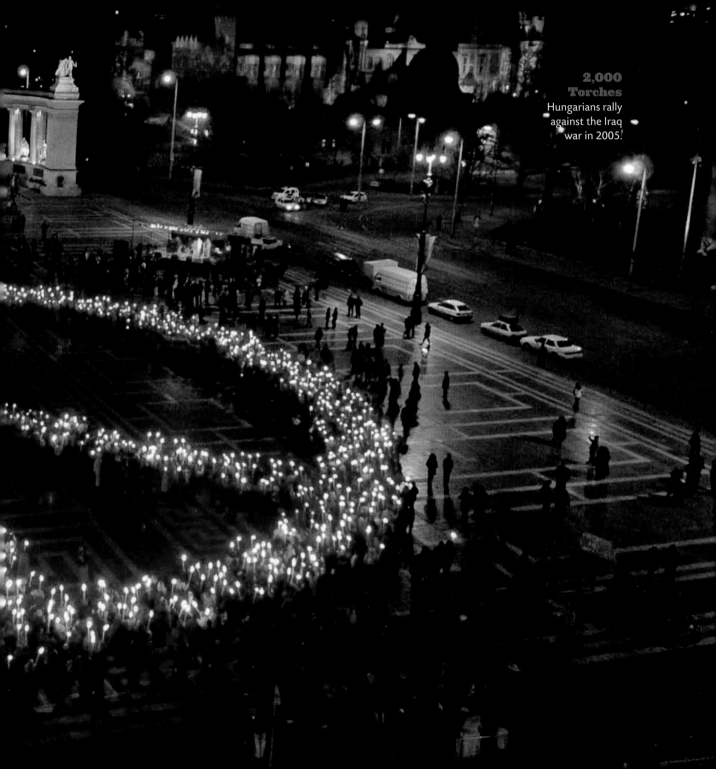

2,000 Torches Hungarians rally against the Iraq war in 2005.

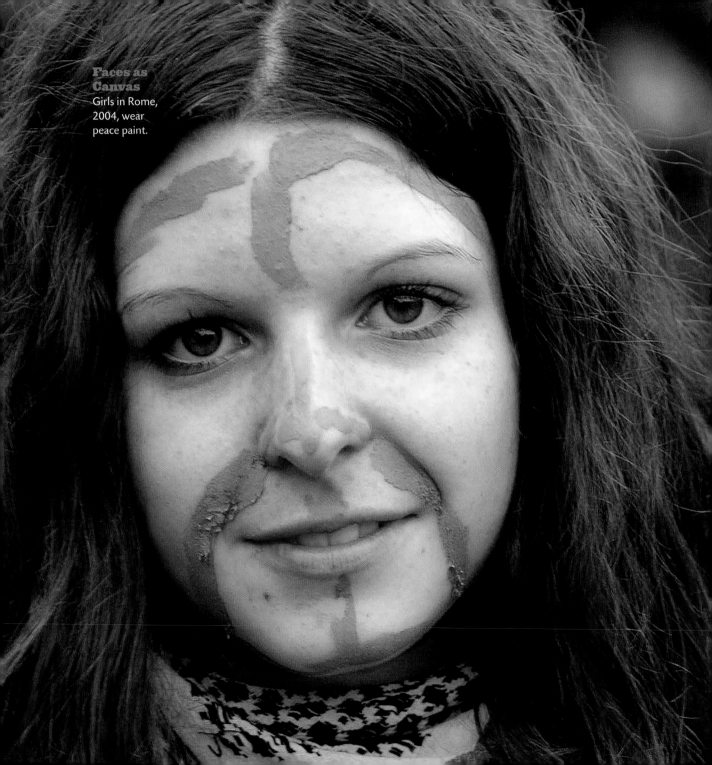

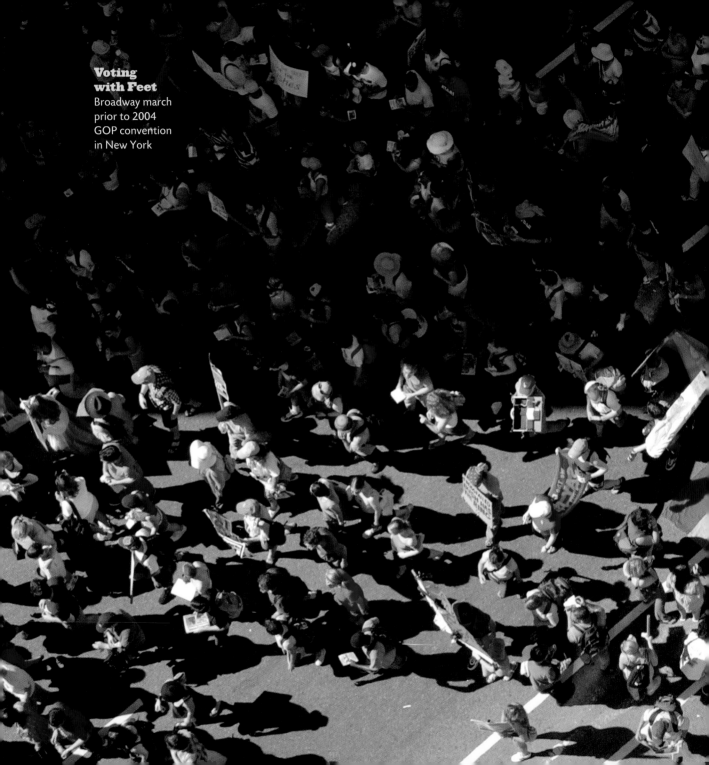

Voting with Feet
Broadway march prior to 2004 GOP convention in New York

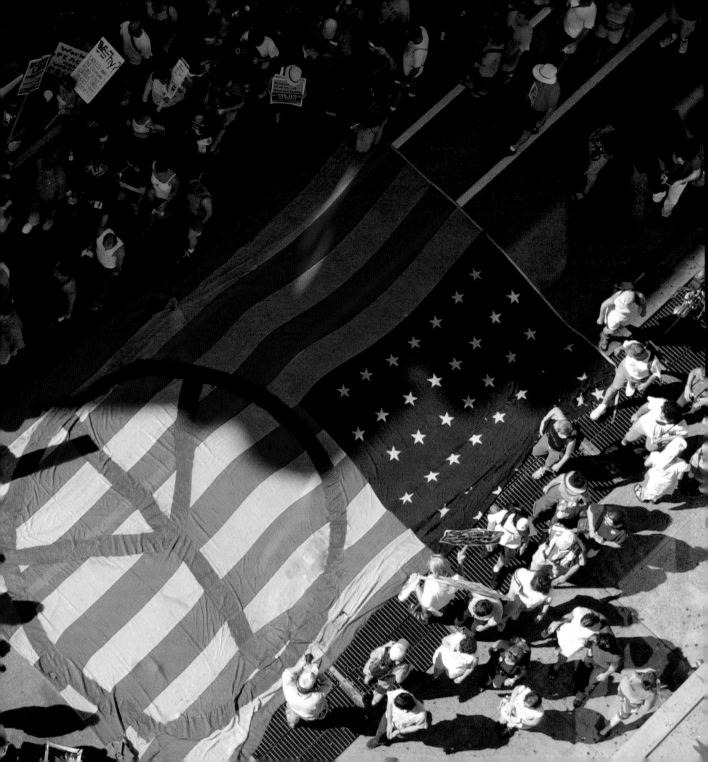

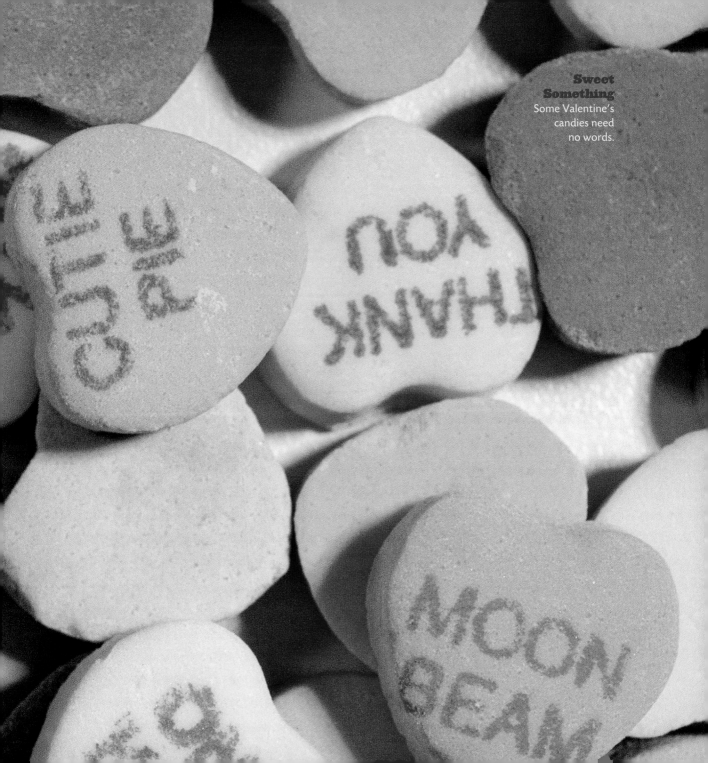

Graffiti
Phantom of peace
on Los Angeles
wall, 1992

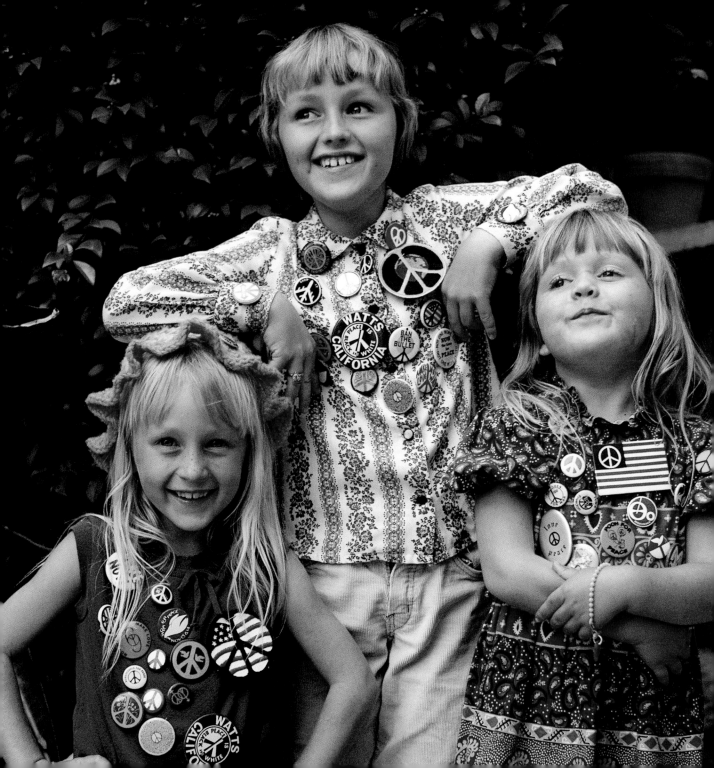

Introduction 16

Chapter One
The 1950s 18

Chapter Two
The 1960s 54

Chapter Three
The 1970s 106

Chapter Four
The 1980s Through Today 144

Epilogue 172

Acknowledgments 174

Illustrations Credits 175

Dressed for Peace Author Ken Kolsbun's children
Tuesday, Holly, and Dawn, sport badges from his collection, 1974.

INTRODUCTION

Responsibility of the individual

I began photographing the peace symbol at the antiwar rallies I attended in the late 1960s, at the height of the Vietnam War. As a father of a young family then, living in southern California, I wasn't part of the hippie movement that was sweeping the state and the country, but I did have strong feelings about war. I vividly remember my World War II childhood in the rural San Fernando Valley—the air **is a concept often** raid sirens, the rationing, the flags in the windows of families with a service member overseas. Fear was a vivid fixture of my childhood, even after the war ended. With the 1950s came a different kind of war, the Cold War, and with it, the threat of nuclear annihilation. The air-raid drills went on, and a new, larger terror replaced the fears of the World War II era. ☮ By the mid-1960s, I had my own child and the country was involved in a new conflict. But the Vietnam War did not rouse the patriotic fervor of World War II. At about that time, I also became friends with my neighbor, Ted Schoenman. Ted's son Ralph had been Bertrand Russell's private **beyond comprehension** secretary and eventually became director of the Bertrand Russell Peace Foundation. Ralph had also been instrumental in organizing the Committee of 100 Against Nuclear War—a strident ban-the-bomb group in London in the early 1960s. Though I didn't know it at the time, all of this connected back to my interest in the creation of the peace symbol. Ralph's information filtered down to his father, who in turn opened my eyes to a broader political worldview, beyond what I had previously learned from my local paper and national television. Soon I had developed a passion for politics and concern about the war. With the 1968 presidential election around the corner, I slapped a McCarthy bumper sticker on our VW Squareback, paid 25 cents for my first peace symbol button,

and let my hair grow a little longer. ☮ Like a lot of other young Americans, I took to the streets to protest the growing involvement **and seldom** in Vietnam. At each one of the demonstrations I attended, the rallying symbol was that circle with what looked like a drooping tree inside it. The peace symbol. Everywhere I looked—on posters, medallions, earrings, cars, graffiti. That simple circle design had become a magnet, an icon for the counterculture and the anti-war movements. ☮ What has surprised me in the decades since is that the peace symbol **put into practice.** continues to exert almost hypnotic appeal. It's become a rallying cry for almost any group working for social change. ☮ With my background in design, I'm fascinated by the simplicity of the peace symbol and how people have used it, worn it, adapted it. Each iteration of the symbol seems unique, because it bears the artistic touch of the person replicating it. The fact that the symbol is easy to recall and draw—just a circle with three lines in it—might account for some of its worldwide recognition and proliferation, but I think it's more than that. ☮ I was fortunate enough to correspond with Gerald Holtom, the symbol's designer, ten years before his death in 1985. He critiqued my original notes on the history of the symbol, which have now culminated in this book. I continue to correspond with some of his children and a nephew. They have all been generous in sharing family photos, diaries, **–Gerald Holtom** letters and notes, and memories. His life story and the symbol's are in many ways inextricably linked. ☮ Certainly, my own life has become intertwined with the symbol and with the pressing need to tell its story, a story I have been documenting through my own photographs, press clippings, and primary sources for decades now. On the 50th anniversary of the peace symbol, I can only hope that it will continue to inspire, and inform generations to come. –Ken Kolsbun

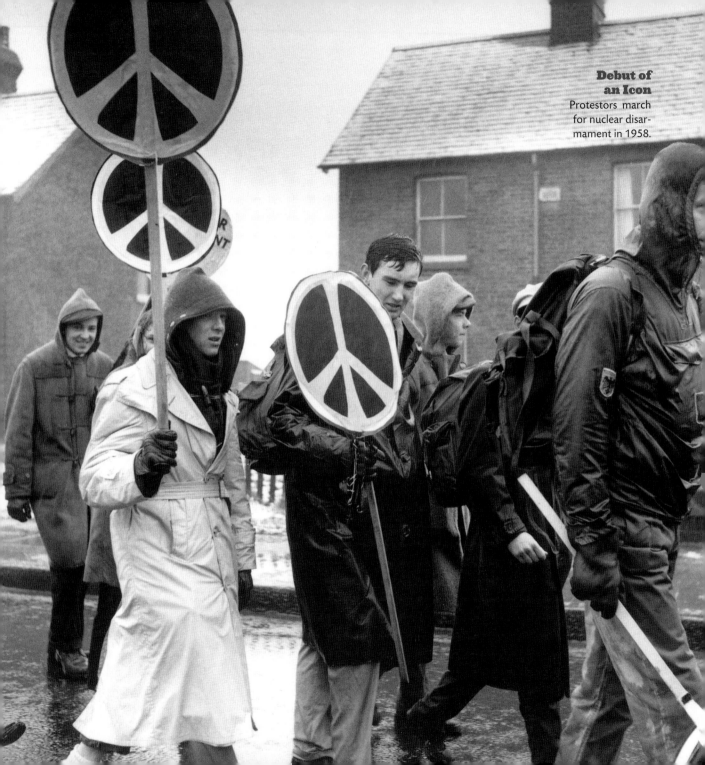

chapter

The 1950s

America's Cold War
Hail, Britannia
CLOSE-UP: Bikini Atoll
Enter a Single-minded Prophet
On to Aldermaston
The Symbol Takes Flight
The Artist and His Struggles

There is one thing stronger

The peace symbol is a unique mid-20th-century creation, a product of recent history. What started out as a symbol designed for a march protesting nuclear war became a worldwide symbol for peace. After too many wars and the buildup of arms, people were looking for peaceful alternatives. ☮ **than all the armies** The 1930s had been a great struggle against aggression and fascism, culminating in World War II. The fifties was a strange decade of contradictions. A booming prosperity and sunny optimism set the tenor of the times, but clouds hovered at the edge of the horizon. Or one cloud—a mushroom-shaped one that threatened more than just the possibility of another war. This **in the world:** cloud could signal the end of humanity, a concept that just years before would have seemed unbelievable. ☮ The U.S. began its top secret Manhattan Project in 1942 as World War II was raging, in response to rumors that Germany and Japan were developing a nuclear bomb. Physicist J. Robert Oppenheimer headed up the team of scientists who worked feverishly to create this new weapon nonpareil. By July 1945, they had succeeded. Just months before, Franklin Delano Roosevelt had died

North Korea invades South Korea	UN headquarters opens in New York	First hydrogen bomb detonated by U.S.	Joseph Stalin, leader of the U.S.S.R., is dead	*Brown v. Board of Education* decision holds school segregation illegal
50	**51**	**52**	**53**	**54**

suddenly and Harry Truman stepped onto the world stage, an inexperienced President with a devastating new weapon **and that is an idea** now in his arsenal and an intractable enemy who refused to bring the war to a close. When that first atomic bomb was detonated in New Mexico, Truman was in Potsdam, Germany, conferring with Winston Churchill and Joseph Stalin on the Japanese resistance. Elated, he told **whose time has come.** Churchill of the successful detonation. Recalling Potsdam, Churchill later wrote: *To quell the Japanese resistance man by man . . . might well require the loss of a million American lives and half that number of British. . . . Now all this nightmare picture vanished. In its place was the vision—fair and bright it seemed—of the end of the whole war in one or two violent shocks.* ☮ A fair vision indeed. "Little Boy" was dropped on Hiroshima on August 6, 1945. "Fat Man" destroyed Nagasaki three days later. The combined death toll exceeded 100,000. ☮ The attack on **–Victor Hugo** Japan contributed to both the end of the war and the alliance between the U.S.S.R. and the U.S. American and British troops slowly returned home. Not so Stalin's Red Army. It sprawled far beyond its national borders, across Central and Eastern Europe all the way to Korea.

Montgomery bus boycott heralds civil rights movement

Elvis Presley performs on *The Ed Sullivan Show*

On the Road, a celebration of the Beat generation, appears

Peace symbol is born in the U.K.

Fidel Castro assumes power in Cuba

55　　　　**56**　　　　**57**　　　　**58**　　　　**59**

AMERICA'S COLD WAR

TRUMAN WAS AWARE OF THE SPRAWLING SOVIET EMPIRE, but he believed the Soviet sphere could be "contained," because the U.S. had something the U.S.S.R. did not. Nuclear weapons.

That is, until 1949. In that one year, the Soviets successfully detonated their own atomic bomb and China's long civil war ended. The communists under Mao Zedong had emerged victorious, adding weight to the ever growing fear of a Red-dominated world. The next year North Korea attacked the South, throwing oil on the Red Scare fire. The Cold War was now on, and the rhetorical and technological engines of the world's two new superpowers, the U.S. and the U.S.S.R., went into high gear.

By 1950, the two were in a committed war of words and of arms. Truman declared a national emergency, warning the nation that "our homes, our nation, all the things we believe in, are in great danger." In 1952, the U.S. escalated the race, detonating a hydrogen bomb. The U.S.S.R. followed suit the next year. In 1956, in an infamous and perhaps misunderstood speech to Western diplomats in Moscow, Communist boss Nikita Khrushchev vowed that "history is on our side. Whether you like it or not, we will bury you."

Meanwhile, air-raid warning systems and school drills became facts of life across America. Sirens would warn children to "drop and cover"—hide under their desks and cover their heads. Some families began building bomb shelters in the backyards or basements of their homes. Russian spies were suspected around every corner. Two such "spies,"

Hiroshima Watch
Relic records moment of atomic blast.

Gas Drill
(Opposite) British pupils practice for emergency, 1950.

American communists Julius and Ethel Rosenberg, were accused and convicted of conspiracy to commit espionage in the transmission of information about the American nuclear bomb to the Russians. They denied the charges, and were executed in 1953.

In the halls of Congress the Red Scare drumbeat was almost deafen-

> **"History is on our side. Whether you like it or not, we will bury you. "**

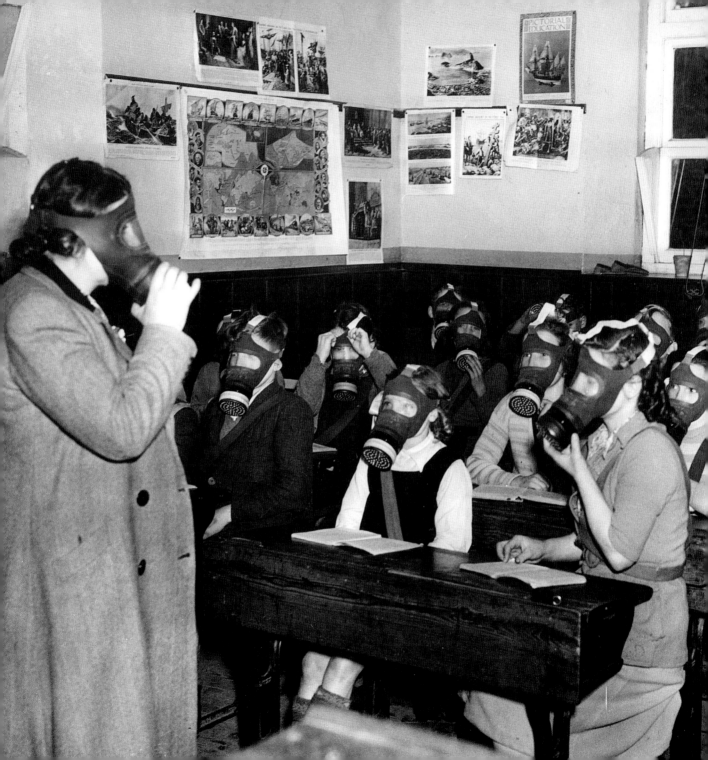

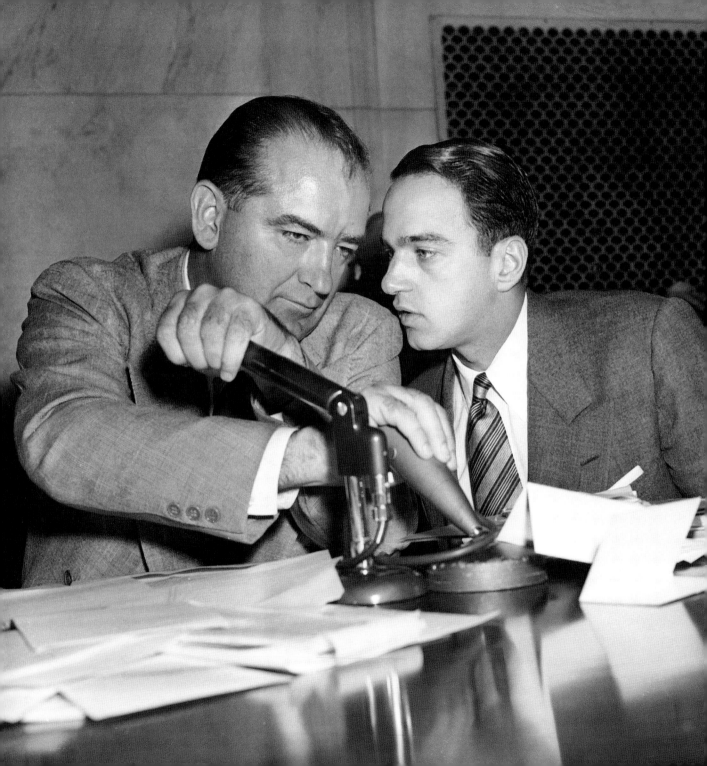

ing, as Wisconsin senator Joseph McCarthy hauled some of America's most prominent citizens before his Congressional committee and asked them if they were or ever had been a member of the Communist Party. McCarthy had come to prominence in 1950, claiming he had a list of 205 members of the Communist Party in the U.S. State Department. For several years thereafter, "McCarthyism" managed to wreak havoc within the halls of government and within academic, artistic, and scientific communities across the country.

Yet despite Red baiting and the Red Scare, America was prospering, and changing. The suburbs—new additions to the American landscape—were gradually emptying cities, as families, now equipped with cars, had the mobility to live without public transportation. Drive-in theaters became a favorite form of entertainment, and electronics ushered in a brave new world filled with TVs whose shows depicted family life, home appliances, and Tupperware. A social conservatism, along with a strong national pride rooted in the arms race and the new space race, defined much of America. ☮

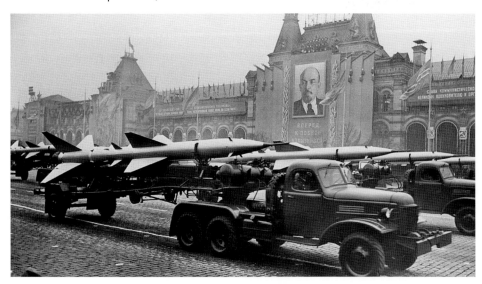

Red Scare
(Opposite)
Joseph McCarthy, left, and Roy Cohn at 1954 hearings

Red Square
Soviet missiles parade outside Kremlin, 1957.

HAIL, BRITANNIA

London Blitz
(Opposite) German bombs threaten St. Paul's Cathedral.

Bertrand Russell
Philosopher, Nobel Prize winner in 1950

IF AMERICA HAD EMERGED FROM THE Second World War with her factories and future more or less intact, Britain had not. The German bombs had scarred London, and to some degree, the indomitable British psyche. It had also destroyed some of Britain's industrial capacity and economic potential. Still a major imperial power at the close of the war, Britain was nonetheless fast losing its colonies, with India independent by 1947 and others following in the late '40s and early '50s. But the United Kingdom was hardly willing to take a backseat on the world stage. It had begun developing a nuclear arsenal in the early 1950s, and a 1954 government white paper focused on "massive retaliation" through the hydrogen bomb.

When the British leadership informed citizens of its intention to test a hydrogen bomb at Christmas Island in 1956, peace groups went into action. They were fearful not only of the U.K.'s H-bomb test but of the proliferation of bombs and nuclear testing by other nations. Radioactive debris in the form of strontium 90 from hydrogen bombs could drift in the upper atmosphere and settle to Earth thousands of miles from the site of the original explosion. There it could contaminate food, be absorbed into the

[
FLASHBACK: 1951

- Gen. Douglas MacArthur, speaking before Congress, proclaims, "Old soldiers never die; they just fade away."
- CBS introduces first color television show, a program hosted by Ed Sullivan.
]

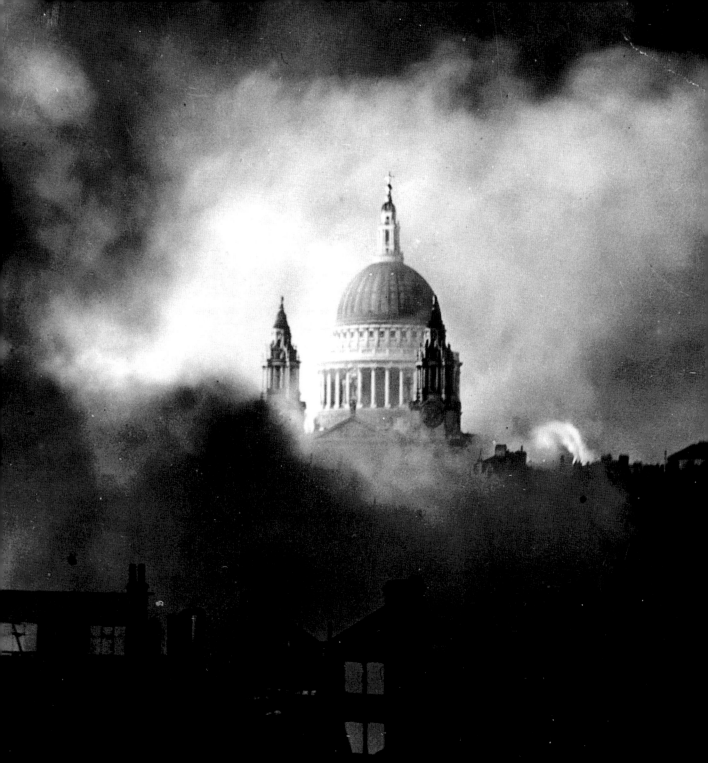

bones of children and adults, and eventually cause cancer. There were reports that strontium 90 fallout on New York City increased by 50 percent in 1957 due to nuclear explosions in the U.S.S.R. the previous year.

In the late summer of 1957, Quaker Harold Steele, Michael Randle, Hugh Brock, Patricia Arrowsmith, and other British peace activists created the Direct Action Committee Against Nuclear War (DAC). It was obvious to DAC members that one more country—their own—having the ability to produce a bomb was not a deterrent to nuclear war; on the contrary, it encouraged other countries to join the arms race. Above all, though, the members of the DAC understood that there was no real defense against a nuclear attack. Considering its relatively small size, Great Britain could be completely destroyed with several large bombs. A chilling thought. After considering various public actions, the DAC decided to hold a protest march aimed at the British Atomic Weapons Research Establishment in Aldermaston, England, some 50 miles from London.

Meanwhile, on January 27, 1958, the National Council for the Abolition of Nuclear Weapons Tests changed its name to the Campaign for Nuclear Disarmament (CND) and formally launched a program aimed at addressing the nuclear issue in Great Britain. CND members were from Quaker and other pacifist religious groups. The philosopher and mathematician Bertrand Russell, who won the Nobel Prize for literature in 1950, was elected CND president. Canon John Collins of London's St. Paul's Cathedral became chairman. The historic first meeting, held at Westminster Cathedral Hall on February 17, featured impassioned speeches by Russell and popular writer J. B. Priestley, both of whom spoke about why nuclear tests and the spread of nuclear bombs must be stopped worldwide. Several hundred then marched toward Downing Street to deliver a petition to Prime Minister Harold Macmillan to ban further testing, but they were violently disbanded by the police. ☮

> "If you ban nuclear weapons completely, they will be manufactured again. The thing you have to do is ban war."
> —Bertrand Russell

Particle Accelerator
(Opposite) Atomic scientists work at Aldermaston.

Fire in the Sky
Mushroom cloud rises over Bikini Atoll.

Bikini Atoll

IN 1945, AFTER THE BOMBINGS OF HIROSHIMA AND NAGASAKI, President Truman issued a directive for nuclear testing to continue. A small, populated atoll in the North Pacific was chosen as the new testing ground. Bikini was one of 30 some atolls and islands in the remote Marshall Islands, scattered across 300,000 square miles of the Pacific. It was chosen because it was far from any air or sea routes. Close to 170 Bikinians agreed to be removed to another island 125 miles away, and after their exodus, nuclear testing began and continued for years.

As the Cold War esca- 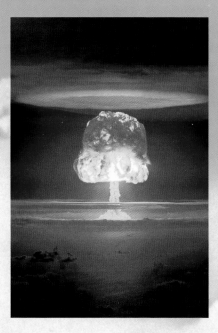 lated, so did the testing, and in 1954 the U.S. mili- tary dropped an H-bomb on the atoll. A thousand times more powerful than the atomic bombs that fell on Hiroshima and Naga- saki, "Bravo" sent millions of tons of sand, coral, and animal life soaring skyward. The white ash of its radioactive fall- out descended on the unsuspecting residents of nearby islands and on the 23-man crew of the *Fifth Lucky Dragon*, a Japanese fishing boat. "The sky in the west sud- denly lit up and the sea became brighter than day," one crew member recalled years later. "We watched the dazzling light, which felt heavy. Seven or eight minutes later there was a ter- rific sound—like an ava- lanche. Then a visible multi-colored ball of fire appeared on the horizon." One crewman died and islanders suffered from radiation sickness.

A small group of Americans and British became concerned about the health haz- ards of nuclear fallout. In the U.S. the Fellowship of Reconciliation (FOR) called for an immediate halt to future tests. To quell public fear, the U.S. Civil Defense Administration published a pamphlet stating "fallout is nothing more than particles of matter in the air." Admitting that these particles were indeed radioactive, the CDA proclaimed that "radioactivity is nothing new...the whole world is radioactive."

In the decades that followed, the Bikinians wandered from island to island in the Pacific. They have filed and won several lawsuits against the U.S. government, but a further lawsuit is pending, claiming that full reparations have never been made. Their island remains plagued by radioactive debris. ☮

ENTER A SINGLE-MINDED PROPHET

> ## "The threats of 'massive retaliation' indicate the degree of insanity achieved by you and your team . . ."

AT FIRST, THE NEWLY FORMED CND did not offer support to the DAC's idea of a protest march, seeing it as too radical. With its largely suburban, middle-class base, the CND tended to think more along the lines of constitutional action—lobbying Parliament, organizing petitions, handing out leaflets. It wanted to play by the rules. Meanwhile, the DAC moved ahead with plans for a march on Aldermaston. Details were finalized in the offices of *Peace News—The Internationalist Pacifist Weekly* in London.

One of the DAC's concerns was providing the marchers with appropriate signs and messages to carry. Seven weeks before the date of the march, the person who would solve that problem walked through the door of the *Peace News* offices.

Gerald Holtom, a textile designer from Twickenham, was highly concerned about the nuclear weapons issue. He knew about the upcoming DAC march and had been putting together his graphic ideas for a symbol for marchers to carry. He had been toying with the idea of using a Christian cross motif, which he presented at the inaugural CND meeting on February 17, 1958.

Holtom had been inspired by the speeches at the meeting. Later, when CND members attempted to deliver a petition to Prime Minister Macmillan to stop nuclear weapons testing, the police violently intervened. In apparent frustration, Holtom wrote to Macmillan, "The threats of 'massive retaliation' indicate the degree of insanity achieved by you and your team . . . men who are at par with the war criminals of history."

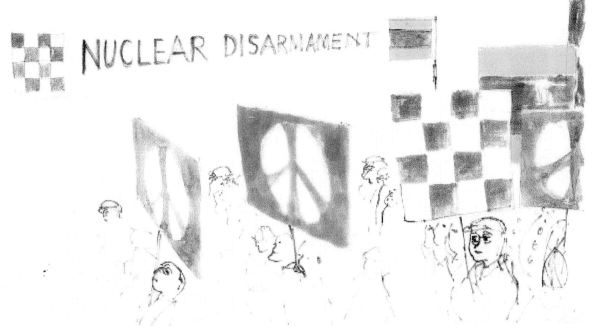

Holtom decided to revise his ideas for the cross motif symbol and knocked on the doors of the DAC with his new design. In a letter from December 1969, Hugh Brock, editor of *Peace News*, described the February 18, 1958, meeting he, Michael Randle, and Pat Arrowsmith had with Holtom:

> *Gerald Holtom, with the single-mindedness of a prophet, was burning with the conviction that the forthcoming march should have a symbol associated with it that would leave in the public mind a visual image that meant nuclear disarmament. He pressed this idea on Pat and myself, and in due course came along to the office again with both a specimen of the symbol and a sketch showing how the slogans should be portrayed. By profession he was a manufacturer of visual aid equipment and for a fortnight he turned*

Holtom's Original Sketch
Marching with nuclear disarmament symbols

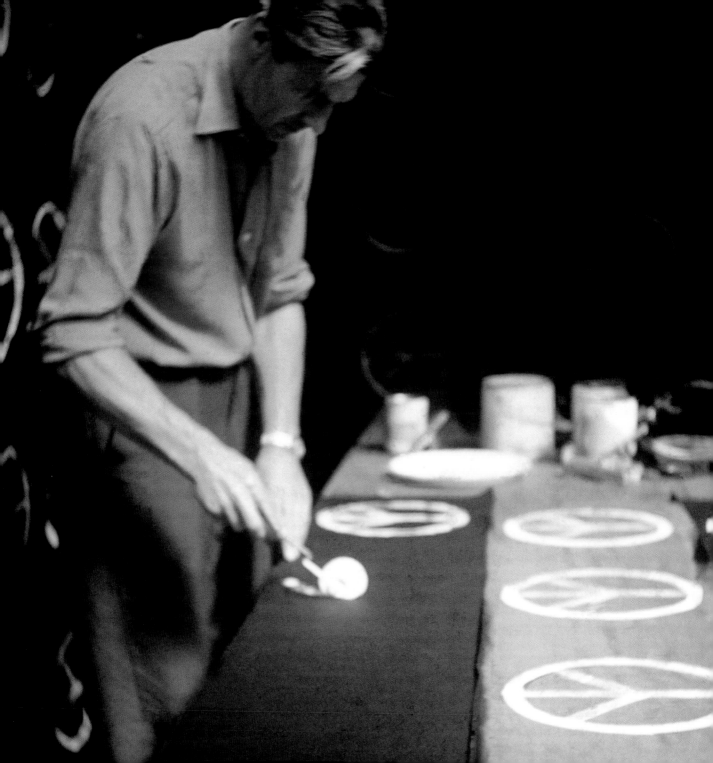

his small factory over to the manufacture of long streamers with slogans on them, while at the same time he gave us directions for the printing and mounting of the first ND symbols, or "lollypops" as they were affectionately dubbed. He was a most wise and practical adviser. He insisted that the symbols be mounted on very light laths of wood so that the marchers could carry them easily on the physically exhausting march, and more importantly, that they be pasted on to light card with waterproof adhesive to withstand bad weather. Quite frankly Pat and I were skeptical about the symbol. Gerald was insistent that it would sweep across the country, and of course events have proved him right. He asked for and was given a completely free hand in giving out the banners to the marchers when they assembled for the start in Trafalgar Square. He had, contrary to the practice in previous marches and demonstrations organized in Britain, all the slogans done in white lettering on black cloth, arguing that these would show up brilliantly in press and TV pictures, and this proved to be absolutely right.

Nuclear Disarmament

N + D = [peace symbol]

In a 1963 article for the British weekly *Spectator*, Herb Greer, an American journalist and playwright, described Holtom's specific graphic vision for the upcoming nuclear disarmament march:

One day, a tall, quietly spoken commercial artist from Twickenham came into the offices of Peace News *carrying a large roll of heavy paper. The artist was Gerald Holtom and on the paper he had sketched out a curious insignia in purple and white, which he thought might be useful for the march. On a dark square was superimposed a white circle with a sort of cross inside it, only the arms of the cross had slipped and were drooping against the lower sides of the circle. Holtom had made the design by combining the semaphore letters N and D: N for nuclear and D, of course, for disarmament. The DAC Committee was doubtful at first, but [on February 21st] they decided to accept the symbol. Holtom was delighted and took over the banner arrangements for the march.*

Semaphore
Two letters join hands for peace.

Holtom Paints the Symbol
(Opposite)
White on black adds visual impact.

FLASHBACK: 1953

- Elizabeth II is crowned Queen of England.
- Dwight D. Eisenhower becomes the 34th U.S. President.
- The Korean War ends.

Present at Creation
(Opposite) Symbol debuts; Arrowsmith's thank-you letter (below).

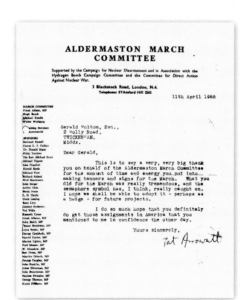

In a 1961 article in *Peace News,* Holtom expanded on the creation of the symbol: "The meaning . . . was more than Nuclear Disarmament . . . the symbol was associated from the onset with the words Unilateral Nuclear Disarmament."

Holtom was convinced that the time of the march was also fortuitous:

This was an Easter March: the ancient Spring Solstice Festival to which Christianity had attached the Celebration of the crucifixion and the resurrection ceremony. From Winter to Spring, from Death to Life. It was my intention to use the black and white symbols on Friday and Saturday and change to green on Sunday and Monday as a token gesture and prelude to a more dramatic revolutionary action, which I had planned to develop in years to come.

Holtom even had the idea for how the marchers should be organized:

The leader was the pace-maker and he was followed by a large banner which simply proclaimed "March from London to Aldermaston" with lettering that passing drivers could see 400 yards away and read at 150 yards. The UND [Unilateral Nuclear Disarmament] Symbol was in gold leaf and at the top corners for luminous reflection of car headlights at night. . .I made pockets in the main banners so that they would take a bunch of spring flowers on Easter Sunday and Monday. Few people noticed them and of those who did, most wept . . . I intended the lollypops to be stuck into the ground on their wood laths at stopping places so that they would appear like a Field of Remembrance in which a great family picnic was taking place. It never quite happened like that, but it might do yet. ☮

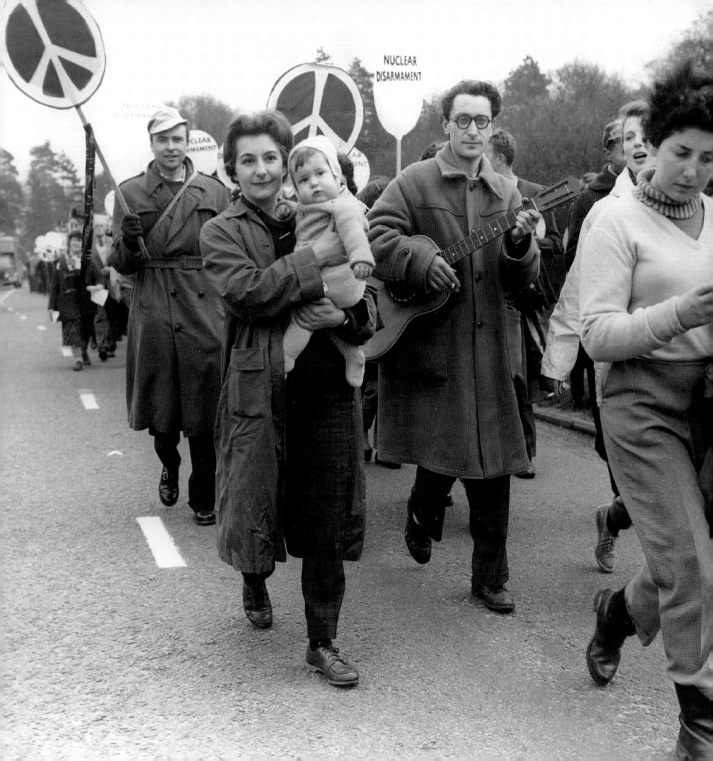

October 13, 1960. If Nikita Khrushchev wanted to set himself apart from the other emninent world leaders attending the fall 1960 session of the United Nations, he succeeded. The Soviet leader "was known for strong language, interrupting speakers, banging his fists on the table in protest, pounding his feet, even whistling," his granddaughter Nina Khrushcheva recalled. He was also famously known for banging his shoe at the UN session. But did he?

Eyewitnesses disagree and no picture of Khrushchev in the act has been uncovered. Khrushchev may have pounded the desk with his fists. Family tradition holds that his watch fell to the floor amid the fist pounding, and when he bent to retrieve it, he espied his empty shoe (he had taken it off), and emerged from below the desk brandishing it. John Lowengard, former picture editor for *Life* magazine, was there, along with almost a dozen other photographers, and he is "certain [that Khrushchev] did not bang his shoe on the desk."

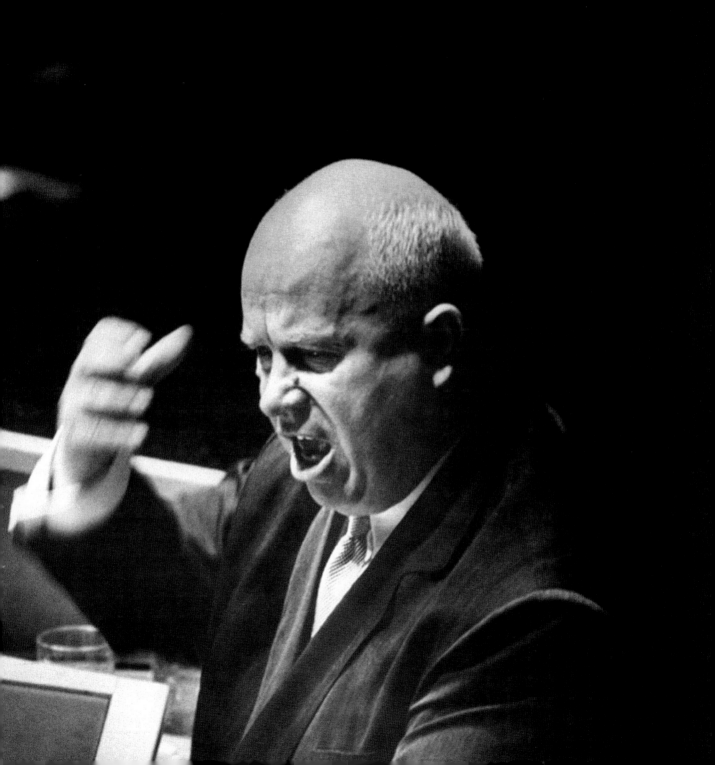

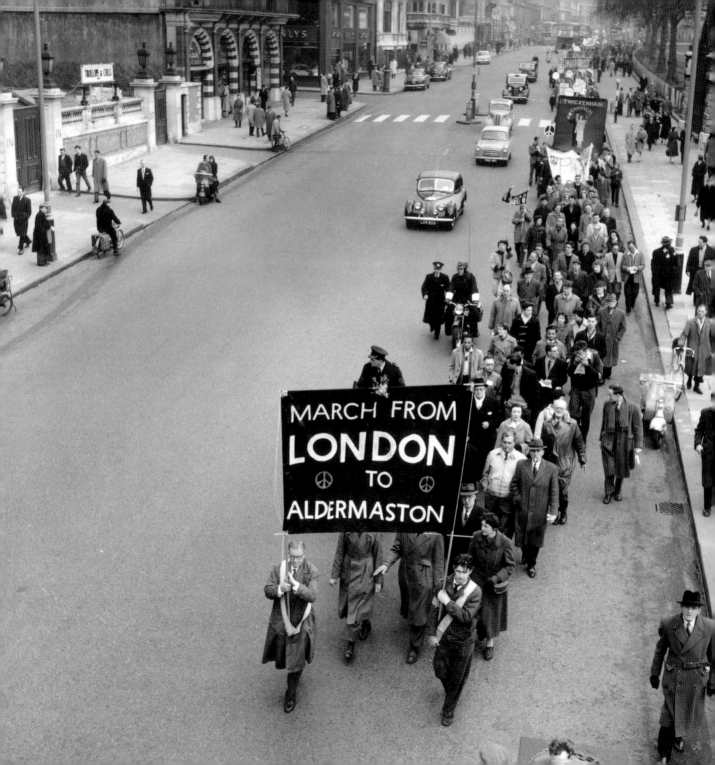

ON TO ALDERMASTON

ON A DAMP AND CHILLY GOOD FRIDAY, April 4, 1958, more than 5,000 warmly dressed citizens gathered in Trafalgar Square to show support for the Ban the Bomb movement and the march on Aldermaston, and to walk the first few miles. After 15 miles, with a few onlookers sneering, some 500 to 600 marchers walked, danced, and sang on, continuing on the 4-day, 52-mile-long march. Along the way, they were often joined by others from nearby towns, who marched with them for a time or came to cheer them on. Singing "When the Saints Go Marching In," "Daughter Fair," and "Down by the Riverside," the marchers knew they were involved in something momentous. Bystanders were seen in tears along the route, watching and wondering. Marchers included clergy, university professors, members of Parliament, laborers, and families. According to Peggy Duff in her 1971 book, *Left, Left, Left*, "While the bomb was its [the march's] main occasion and theme, it was much more than that. It was a mass protest against the sort of society which had created the bomb, which permitted it to exist, which threatened to use it. "

Nearing Aldermaston's atomic weapons research plant, the core marchers were joined by hundreds more, who came by foot, car, and bus. Everyone arrived in complete silence. Thousands more lined the road to show their support. Describing the historic event in the April 17, 1965, edition of the *Saturday Review*, Norman Moss wrote:

> By the end of the march on Easter Monday, 10,000 people were standing in a wet and chilly field opposite the barbed wire perimeter of the Aldermaston's plant to hear the speeches. Something new had happened. … The Ban the Bomb movement in Britain was a unique phenomenon and an important one. There has been nothing quite like it anywhere else in the world. It is a special product of the British circumstances and the British conscience.

FLASHBACK: 1957

- Soviet Union launches Sputnik.
- Martin Luther King, Jr., becomes the first president of the Southern Christian Leadership Conference (SCLC).

Onward to Aldermaston
(Opposite) CND marchers take to London streets.

Trafalgar Square
(Following pages) First public display of Holtom's symbol, April 4, 1958. Ten days later, the symbol crossed the Atlantic when this photo was published in *Life*.

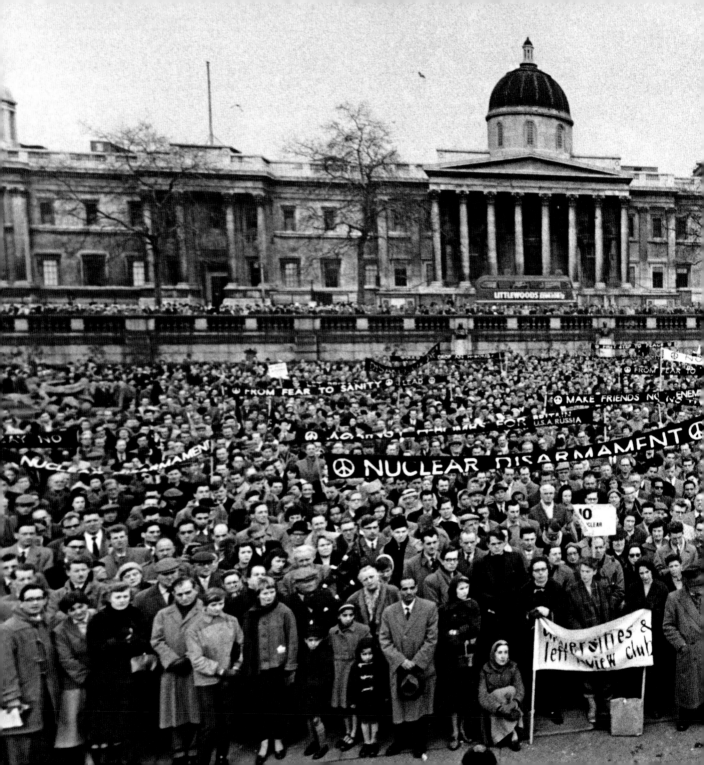

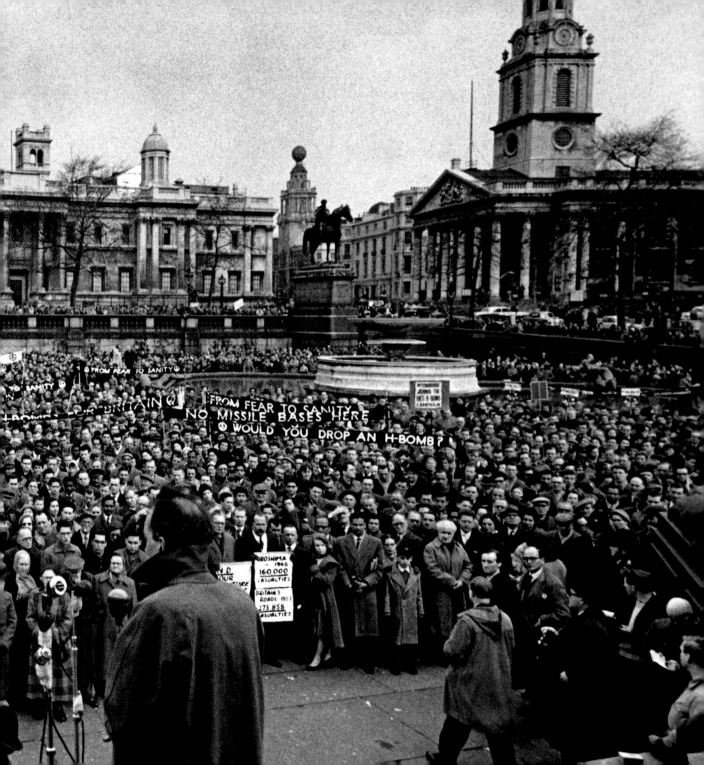

News coverage of the antinuclear events of 1958 ridiculed the efforts of the organizers. The *Times* of London portrayed the rallies and marches as "Stalinist." One *Times* headline read "Scuffles as Marchers Reach Aldermaston." The article focused on one counterdemonstrator who was harshly critical: "Marchers, every one of you is guilty of increasing the risk of war . . . you are voting with your feet for Soviet imperialist domination . . . most of you have been bamboozled into supporting Communist aggression and butchery." The press reported little about the spiraling nuclear arms race or the goals and objectives of the DAC and CND. Both the *New York Times* and the London *Times* incorrectly reported that the march was organized by the CND rather than by the DAC.

> **"Marchers, every one of you is guilty of increasing the risk of war..."**

Ironically, the same issue of the London *Times* included a story about how the Soviet News Agency, Tass, reported the event: "Marchers were greeted with shouts of approval and applause from the local residents . . . a similar welcome, indicative of the people's whole-hearted support for the demand for an end to the nuclear arms race, has been given to the marchers in virtually all towns and villages on their way." One teenager was pictured marching behind a placard that read "We Don't Dig Doom."

The American pacifist Gene Sharp, then assistant editor of *Peace News,* wrote after Aldermaston, "Britain will not be the same again. The greatest peace march in British history has taken place. . . . In their hundreds and thousands, men, women, and youths tramped in cold, wind, snow, and a little sun to demonstrate . . . their opposition to testing, making and storing nuclear weapons in Britain."

"Lollipops"
(Opposite)
Holtom's easy-to-carry signs lay stacked against a tree during the first Aldermaston March.

A few months after the 1958 march, Holtom met ceramic artist Eric Austin. For the second Aldermaston march, in 1959, now run by the CND, Eric made small white ceramic discs on which he painted the peace symbol in black slip, then fired them, and attached pins with adhesive on the backside. The badges were distributed bearing a frightening message: "In the event of a nuclear war, these fired pottery badges would be among the few human artifacts to survive the nuclear inferno." ☮

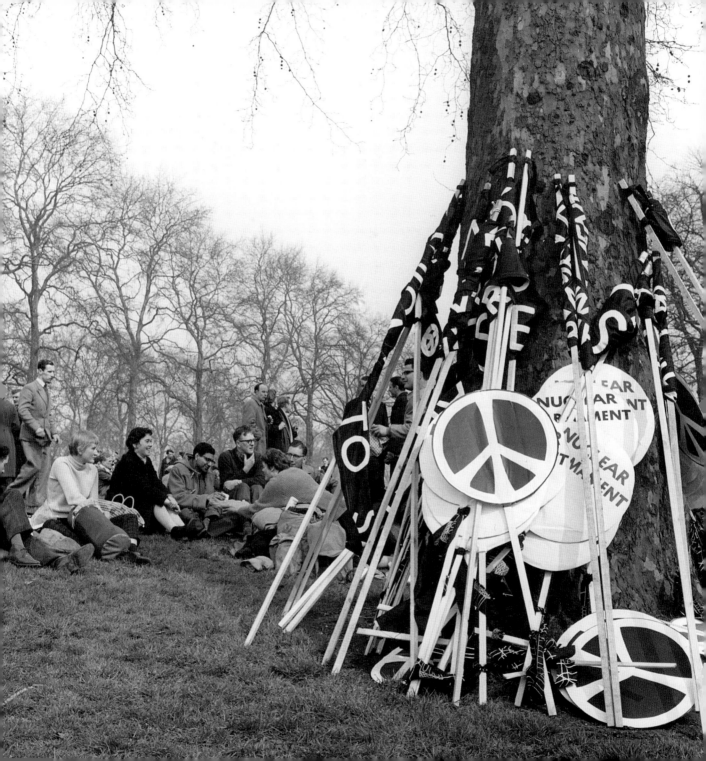

THE SYMBOL TAKES FLIGHT

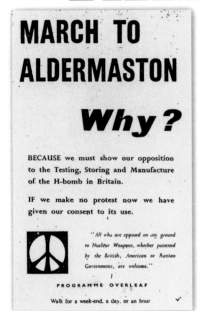

MARCH TO ALDERMASTON

Why?

BECAUSE we must show our opposition to the Testing, Storing and Manufacture of the H-bomb in Britain.

IF we make no protest now we have given our consent to its use.

"All who are opposed on any ground to Nuclear Weapons, whether possessed by the British, American or Russian Governments, are welcome."

PROGRAMME OVERLEAF

Walk for a week-end, a day, or an hour

Flyer
Protest circular displays the peace symbol.

Committee of 100
(Opposite) Bertrand Russell, center, and Ralph Schoenman, right, walk for peace.

HOLTOM'S SYMBOL STARTED APPEARING EVERYWHERE, not just at Aldermaston marches. It was sewn on flags, worn on clothes, and even scratched on walls and signposts all over Europe. "Designers loved it," Peggy Duff reported. "They took it and played with it, made it tiny and enormous, twisted it, cut pieces off it, but always it was unmistakable."

By 1961, demonstrators in over 30 countries had staged their own versions of the Aldermaston march, but some members of the DAC and CND, including Pat Arrowsmith and Ralph Schoenman, a dynamic and persuasive young CND member, felt it was time for new blood, a broader view, and a new approach. They proposed a Gandhian method of protest—nonviolent civil disobedience. Bertrand Russell agreed, resigned from the CND, and became president of the newly formed Committee of 100 against Nuclear War. The DAC was soon absorbed into this new organization.

The strategy of the committee was simple and direct. They would bring together a hundred well-known citizens who were willing to commit to civil disobedience. This group of a hundred would sit down en masse, time and again, wherever they would be most noticed. It was hoped that the sight of these famous and respected individuals, including Bertrand Russell and actress Vanessa Redgrave, willing to break the law for a cause, would inspire others to action.

The Committee of 100 staged their first sit-down at London's Ministry of Defense on February 18, 1961. Over time, they also organized sit-downs at the Soviet and American Embassies in London and at the American Polaris Submarine Base in Scotland. As these sit-downs drew more and more supporters, many participants were arrested. Eventually, Lord and Lady Russell were arrested. "The sight of the old philosopher being driven away in a Black Maria stirred not only the campaign but the whole of Britain," wrote Peggy Duff. On one infamous day, police arrested a record-breaking 1,140 people.

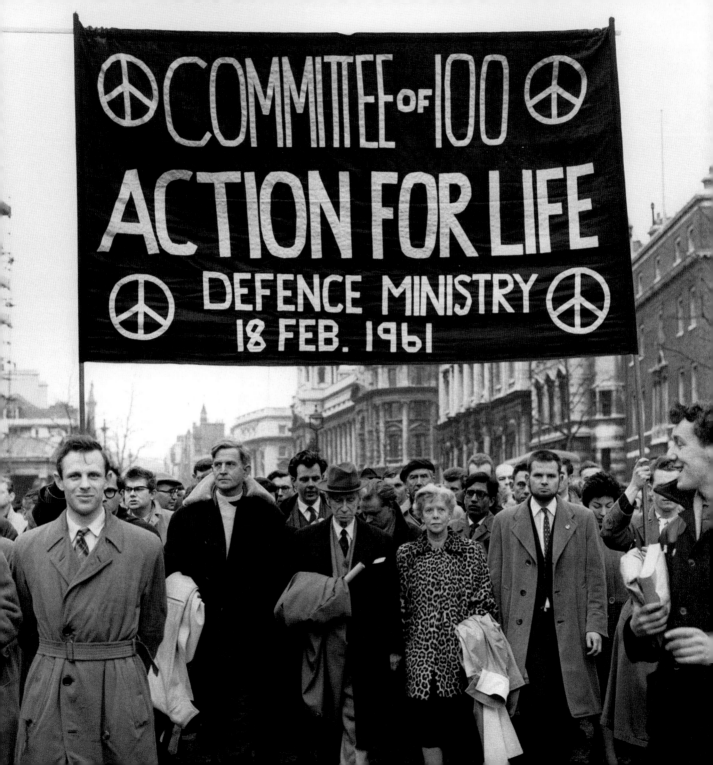

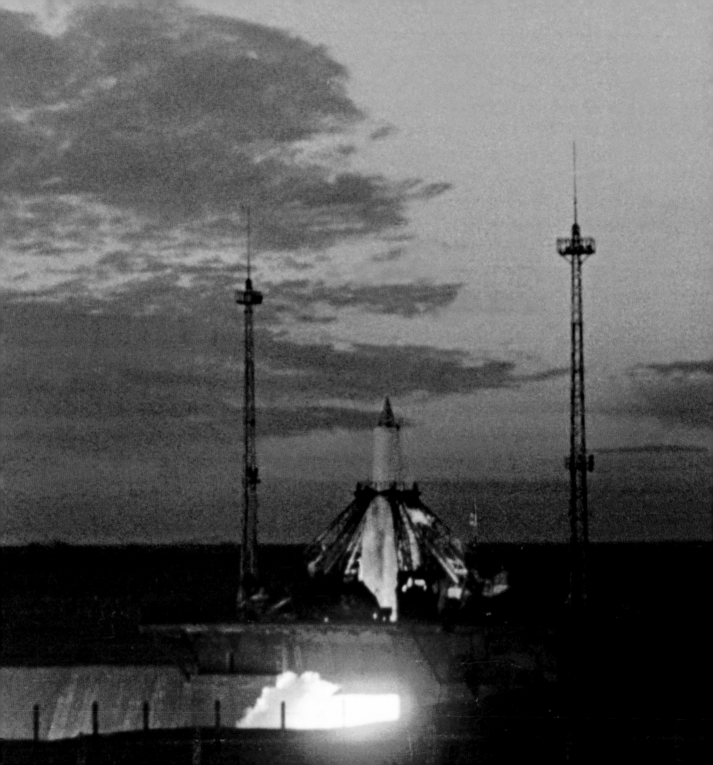

Describing the Committee of 100's significant impact on society, DAC member Michael Randle wrote in *Campaigns for Peace* that it

coincided with a renaissance in British cultural and artistic life, and a majority of those involved in this cultural renaissance, especially the playwrights, but also poets, critics, producers, and singers, were either members of the Committee of 100 or actively involved in its campaigns. In fact the Committee's activities should be seen in the context of this wider cultural and artistic movement which itself represented a rebellion and a demand for radical change.

Around the world, Committees of 100 were formed, even as the superpowers faced off against one another with ever more sophisticated nuclear arsenals and a new space race. When the U.S.S.R. launched Sputnik in October 1957, it took the first prize in that race, beating the U.S. into orbit and leaving America anxious and scrambling to catch up.

As to the arms race, by the late 1950s both the U.S. and the Soviet Union had ICBMs—intercontinental ballistic missiles—stored underground in hardened silos that also served as launching sites. The only "good news" about the arms race was the notion of deterrence, or what the future U.S. secretary of defense Robert McNamara called "mutual assured destruction—MAD." Against all odds, MAD did keep nuclear destruction at bay, but it did not prevent the winds of war from blowing up again.

As the decade came to an end, the U.S. was being drawn inexorably into the civil war between newly formed communist North Vietnam and the corrupt but noncommunist government in the South. Ever fearful of the "domino effect"—a theory promoted by Dwight Eisenhower in 1954 that predicted the countries of Southeast Asia would fall one by one to the spread of communism—the U.S. was quietly and unofficially backing South Vietnam.

Meanwhile, a shift in thinking was being incited in the minds of many Westerners, particularly the young. In the decade to come, their disaffection for war would blossom into a movement. And Holtom's symbol would lead them. ☮

FLASHBACK: 1958
- Nikita Khrushchev replaces Nikolai Bulganin as head of the Soviet Union.
- Hollywood releases *Gigi*, *Cat on a Hot Tin Roof*, and *Marjorie Morningstar*.

Space Race
(Opposite)
A Soviet rocket launches Sputnik in 1957.

THE ARTIST AND HIS STRUGGLES

Gerald Holtom

GERALD HOLTOM WAS BORN IN SHERINGHAM, ENGLAND, on January 20, 1914. In his own words, he was, as a boy, "rather backward, good at sport and happiest when painting watercolors by myself." He was also fascinated by the text and illustrations of the 22-volume *The Times History of the War*, and he pondered the evolution of armaments, as well as the fear and apathy associated with them as he grew up. When he was 21, he followed developments at the Disarmament Conference of 1932, when various heads of foreign governments met with King George V at the Geological Museum in London. The conference had quite an impact on him. Almost 40 years later, Holtom recalled in a letter to his longtime friend Hugh Brock that "Mr. Maisky of the U.S.S.R. proposed complete disarmament as the only rational solution to World Peace. This was greeted by howls of ridicule by the Press. It dawned on me then that countries could not be disarmed by force, without recourse to war, even if they wished to disarm others in 1935."

During World War II, Holtom took conscientious-objector status and worked on land in Norfolk, England. After graduating from the Royal College of Arts in London, he became a self-employed artist, designing printed cloth and textile appliqué wall hangings and curtains; later in life, he designed a hydrofoil sailing craft. But his most famous design was the peace symbol.

In a letter to Hugh Brock, Holtom recalled his first design, based on the cross: "In a hasty survey, all the church leaders who I interviewed refused point blank to associate their religions with the March project." He had assumed that since Canon Collins of St. Paul's Cathedral, the newly appointed chairman of the CND, had agreed to publicize the march, many of his parishioners would want to carry a Christian cross symbol.

He [Collins] replied that it was very doubtful indeed whether any of his parishioners would carry a Christian cross on the London to Aldermaston march. I was stunned and depressed and I therefore set off to interview about 12 priests of various denominations. The face of one turned into a gargoyle's expression as he crossed himself. The other spoke

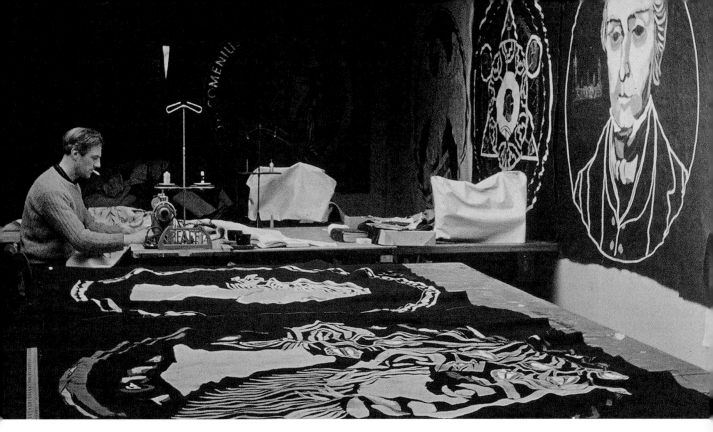

holy damnation at me through a chink in the door. I tried to explain . . . that my job of
making huge fabric murals often for churches including Catholic churches had kept me
deeply connected with Christian moral principles. . . . At this he fetched his growling dog
and the door opened a little wider.

In the end Holtom designed a simple circle with three drooping lines "to mean a human being in despair, with one branch or arm slightly higher than the other." His teenage daughter, Anna, helped mass-produce the 500 peace "lollypops" in his Twickenham textile workshop. The whole family, including the three other children, Ben, Julia, and Peter, participated in the march. "During my life, the maximum effort of endurance and endeavor which I have achieved was the preparation and organization of the visual effects of the First Aldermaston March," Holtom maintained.

Holtom's Studio
The artist works with a fabric design.

His peace efforts began to take a toll on his personal life. Four years after the march, he and his wife Madeleine divorced. Anna felt that "her father's time and energy with the ND movement put considerable financial pressure on his family which later resulted in family disputes and probably contributed to his later divorce."

Holtom soon thereafter married an artist, Charmian, and had two children. Their daughter, Rebecca, describes her father as a "very extroverted man, cheerful, angry, domineering, highly intelligent, artistic, inventive—in fact he was just pure in thought and maybe almost born before his time. . . . He had no particular political [as in political parties] or religious leanings." Others described him as quietly spoken, wise, and passionate—a practical advisor who insisted on high standards and who spoke with immense fervor. Rebecca's brother, Darius, felt that though their father had a good sense of humor, he "had such high ideals he was always under pressure and isolated from the 'herd' as most artists are. In this respect deep down he may have been a lonely man."

Reminiscing later about the third Aldermaston march, Holtom wrote:

People met on the way were different from those of only three years before. A change was taking place, and so, I suppose, it no longer seemed right to display a "despair" symbol. I turned my own badge round to UD [Unilateral Disarmament] but I was wrong. If today there are 1,000 million people who subscribe to ND, that is not enough. If there are 2,000 million people that is not enough. To subscribe to ND is not enough. One must teach one's children to cultivate, to produce power from gravity, sunlight and wind, (all quite easy) and to learn how to live in such a way that others may live here-after. . . . I like the thought that perhaps my little symbol may be remembered among the myriad of truth; that living truth upon which action may be based.

Gerald Herbert Holtom died in Canterbury, England, on September 18, 1985, at the age of 71. In his will, he wrote, "I wish to be buried in Hythe at Seabrook and my gravestone to be carved with an inverted Campaign for Nuclear Disarmament symbol." Two ND symbols were carved on his gravestone, but for unknown reasons they were not inverted. ⊕

Holtom's Headstone
(Opposite) Holtom's grandchildren, Chloe and Gabriel, stand by his headstone.

Passion in Print
Holtom issues a plea to *The Observer*.

GROSVENOR HOUSE, TWICKENHAM
Popesgrove 6441

25th March, 1958.

The Editor,
"The Observer"
22 Tudor Street,
E.C.4.

Dear Sir,

Our Church leaders are crucifying Morality.

Every working man and woman in Britain and every taxpayer is assisting in the manufacture of weapons of mass extermination.

Just as the German contractors and manufacturers made the gas chambers for Hitler in 1937 to preserve their way of life, we are making H.Bombs for the same purpose.

The U.S.A. and the U.S.S.R. are also making these weapons of mass extermination and many other countries are working to do the same.

Nearly 104,400 of us in Twickenham are sitting down and wtaching this happen, elsewhere many millions.

I appeal to your readers to use their brains and energies to devise a new way of life.

Yours faithfully,

Gerald Holtom.

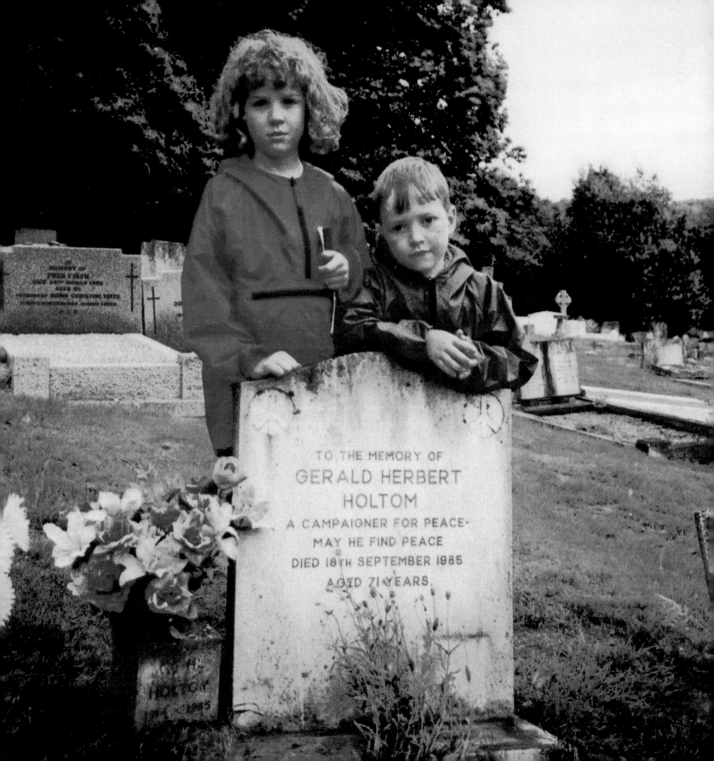

TO THE MEMORY OF
GERALD HERBERT
HOLTOM
A CAMPAIGNER FOR PEACE·
MAY HE FIND PEACE
DIED 18TH SEPTEMBER 1985
AGED 71 YEARS

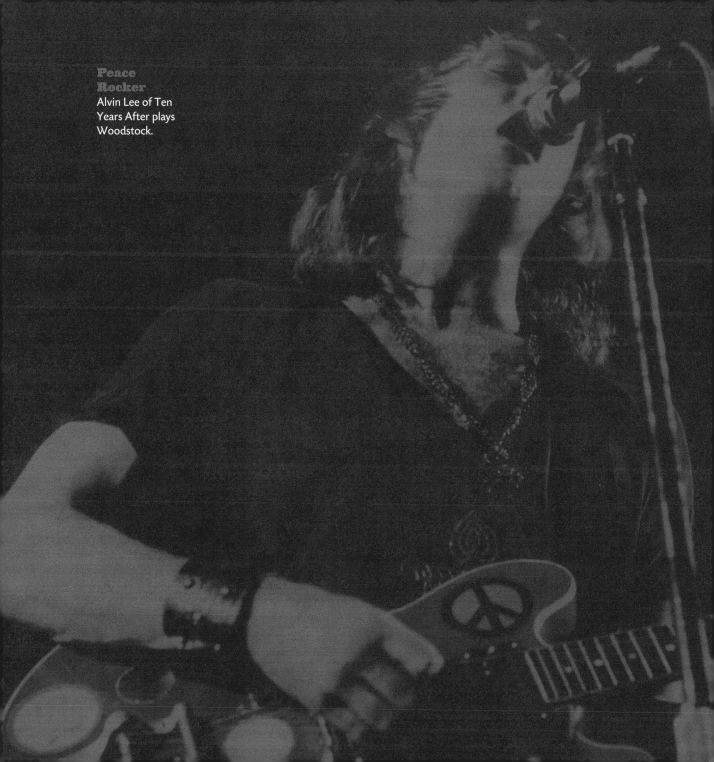

Peace Rocker
Alvin Lee of Ten Years After plays Woodstock.

chapter

1960s

Polaris & Peaceniks
Motherhood Fights for Peace
Hopes Rise for Civil Rights
CLOSE-UP: Pete Seeger
The Vietnam War Divides America
CLOSE-UP: Tinker Case
Seeds of Liberation Take Root
The Counterculture Seeks Its Own Path
Enter Abbie Hoffman
CLOSE-UP: Fillmore West
Woodstock Nation

"Human War has been

The peace activists heard it all the time. ☮ "You're for peace? Why not tell it to the Russians? They're the ones who want war." ☮ Russia— or, more accurately, the Soviet Union— inspired fear throughout the United States as the 1950s gave way to the 1960s. The arms race took a new twist as flag bearers of the Cold War extended the conflict into outer space. The Soviets, who launched Sputnik as **the most** the first artificial satellite in 1957, put the first human into orbit when Yuri Gagarin circled the Earth for 108 minutes on April 12, 1961. America's Alan Shepard followed three weeks later. All over the world, people looked up and wondered whether humanity's first steps into the dark void of space would bring an era of peaceful exploration, or the end of the world in a hail of missiles. It was no idle speculation. The Soviets' puppet government in East Germany began to build the Berlin Wall in the summer of 1961, under-scoring the divide between **successful** the communist East and democratic West. A year later, a showdown over the Soviets' decision to base nuclear missiles in Cuba ended when the weapons were peacefully withdrawn,

Sociologist C. Wright Mills advocates a "new left" in the U.S.

Valium is invented

Beatles record their first album, *Please Please Me,* in the U.K.

President John F. Kennedy is assassinated

Civil Rights Act becomes law

60 **61** **62** **63** **64**

but not before untold numbers of American families prepared desperate plans for surviving a nuclear holocaust. Meanwhile, **of all our** in far-off Indochina, long-simmering conflicts threatened to grow into all-out war. ☮ Many people questioned why things had to be so frightening. If government, capitalism, higher education, and religion had led the planet to the brink of destruction, then what good were they? Historian Arthur Schlesinger, Jr., later an aide to President John F. Kennedy, wrote in January 1960, "The Sixties will probably be spirited, articulate, inventive, incoherent, turbulent, with energy **cultural traditions."** shooting off wildly in all directions." He was right. Activists channeled their energy into protests for civil rights and nuclear disarmament and against the values of previous generations. Quietly at first, a counterculture emerged that opposed authority and materialism while embracing new forms of music, art, sexual conduct, and ultimately, even consciousness itself. Each new movement found its own meaning in the peace symbol, from opposition to war to the demand for civil rights to the utopian dream of the hippie lifestyle. Gerald Holtom's quiet little design took a wild ride in the 1960s. **–Robert Ardrey**

First American combat troops arrive in Vietnam

Black Panthers is founded

Summer of Love is celebrated in San Francisco

Martin Luther King, Jr., and Robert F. Kennedy are assassinated

Apollo 11 lands on the moon

65 **66** **67** **68** **69**

POLARIS &
PEACENIKS

IN THE SUMMER OF 1960 a small band of activists, the Polaris Action pacifists, handed out leaflets at the submarine pens in New London, Connecticut, a coastal community dependent on nuclear submarines for its daily bread. The protestors wanted New London to cast that bread upon the waters—to shun violence for the benefits of peaceful resistance.

It was a long shot, to say the least, and the protests sparked tensions throughout the year. Protest coordinator and Quaker Bradford Lyttle didn't equate nonviolence with non-action. As a young man in the mid-1950s, he had spent nine months in a federal prison for refusing to submit to the draft. When the dream of "atoms for peace" gave way to a nuclear arms race, Lyttle thrust himself into the front lines of the Cold War. He led efforts to breach dock security and interfere with submarine production up and down the East Coast. He worked to block the launching of newly completed Polaris submarines, each of which could shower the Soviet Union with nuclear missiles. Members of his Polaris Action group, working under the umbrella of the Committee for Nonviolent Action (CNVA), even managed to swim to the Polaris sub *Ethan Allen* and hoist themselves aboard.

Lyttle and his Polaris Action group had little immediate impact. As CNVA protested, America's arsenal of atomic bombs grew to 1,500, enough to destroy every major city on Earth. Nevertheless, some prominent Americans talked of surviving, or even winning, a nuclear war. "With proper tactics, nuclear war need not be as destructive as it appears," Henry Kissinger, then a Harvard professor, said in 1957.

In 1960, just two years after Holtom's symbol had made its debut in England, the distinctive circle with three lines appeared in the corner of a CNVA circular. It may have been the first time the peace symbol was enlisted in an American cause, but it would certainly not be the last.

The following year, Lyttle and other pacifists pondered those taunts about taking their peace pleas to the Russians and decided the taunters had a point. Why not take their message to the Russians? Surely, Americans didn't have a monopoly on fear.

Eleven CNVA marchers set out from San Francisco on December 1, 1960, bent on walking 6,000 miles to Moscow. They trudged through Arizona, New Mexico, the Texas Panhandle, and

CNVA Flyer
Protesters target Polaris submarines.

Polaris Seascape
(Opposite) Nuclear sub surfaces off Connecticut in 1964.

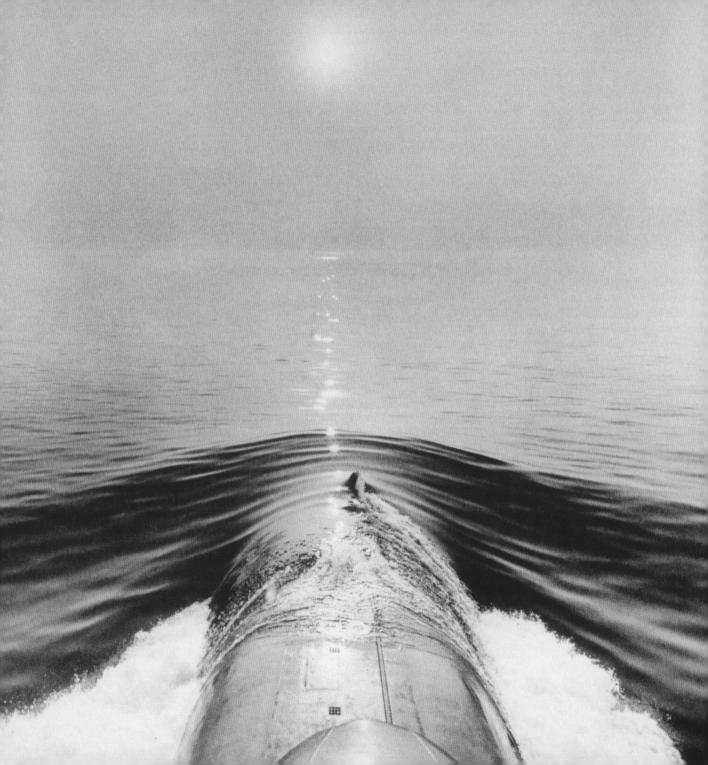

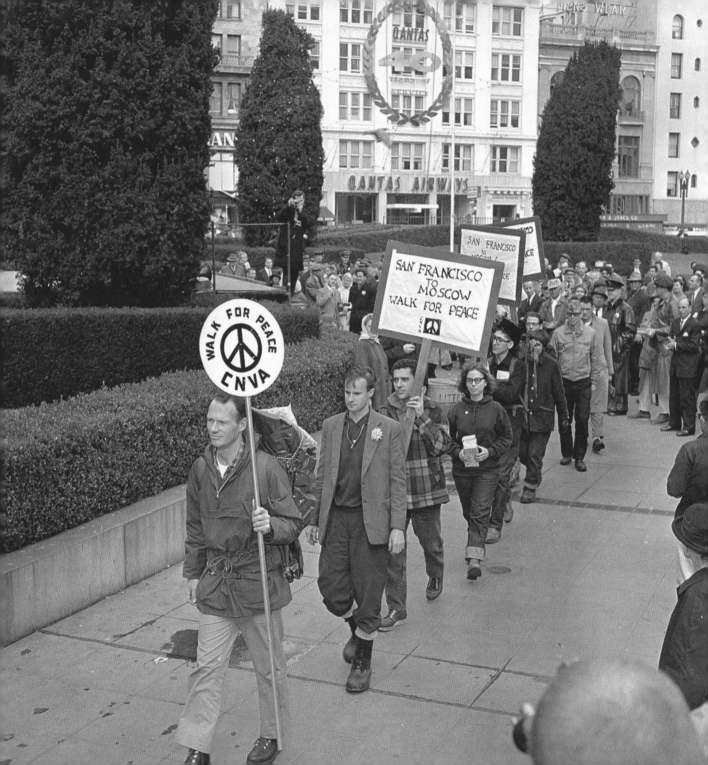

much of the Bible Belt, and on to Chicago and New York. Most media covered the walk as if it were a stunt. "Peace Walkers Here With Aching Tootsies," read one headline. Ordinary citizens paid heed. About 2,000 people walked some part of the way from San Francisco to New York.

After flying across the Atlantic, a core of marchers linked up with Western European sympathizers and continued through parts of England, France, the Netherlands, and Belgium, always changing their posters to reflect the local language. Behind the Iron Curtain, they continued on across East Germany and Poland, and on to the Soviet Union with a message of peace. The San Francisco to Moscow Walk for Peace ended with a vigil in Red Square on October 3, 1961.

Once again, Lyttle had his leaflets handy. This time, the leaflets and placards bore the message "Bread not Bombs" in Cyrillic script surrounding the peace symbol. Although the Soviet government refused to allow speeches, the marchers communicated in elementary Russian as they handed out copies of their message.

> **"Why don't you share your message with Americans? They're the ones who want war."**

"I went to jail because I refused to serve in the U.S. Army," Lyttle told the Russians in the square. "I have protested against American rockets aimed at your cities and families. There are Soviet rockets aimed at my city and family. Are you protesting that?" The marchers felt as if they had stepped through Alice's looking glass. In Eastern Europe, spectators asked: "Why don't you share your message with Americans? They're the ones who want war." Yet many got the message. Some of the marchers, and some of the Russians, cried over their fears for the future. "I was thinking how much they wanted peace, and how little they knew how to get it," one of the marchers said.

Among American conservatives, Polaris Action and the San Francisco to Moscow Walk for Peace made easy targets. Disarming during the height of the Cold War meant trusting, or at least working with, enemies who had been demonized for the past decade as atheists bent on world domination. Furthermore, the pacifists supporting nuclear disarmament provoked controversy by opposing, and in some cases interfering with, the American military. Opponents in the U.S. felt comfortable attacking the message *and* the messengers. ☮

Long Walk
(Opposite)
CNVA marchers
set out from
San Francisco.

Moscow Greetings
(Following pages)
Trekkers
arrive in Moscow
to promote peace
at the Kremlin.

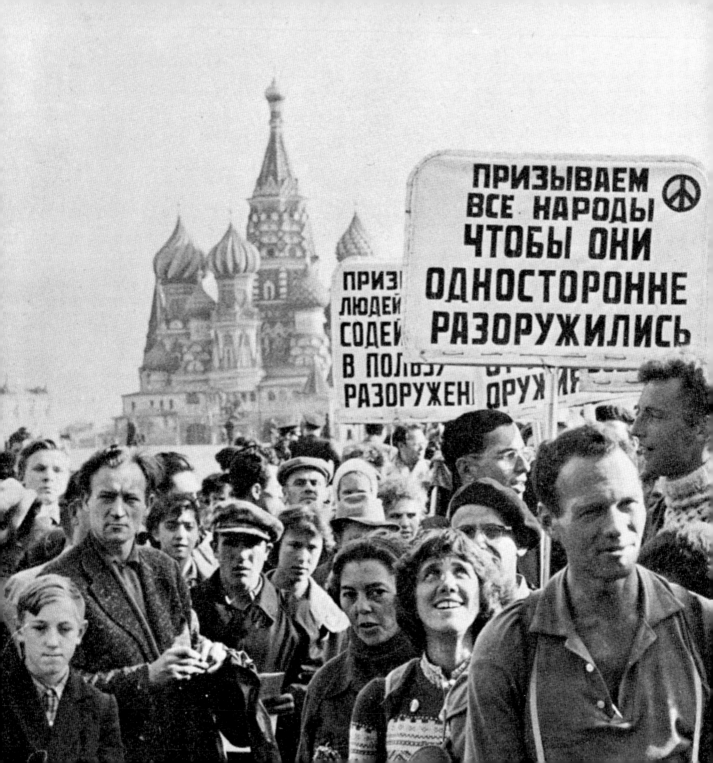

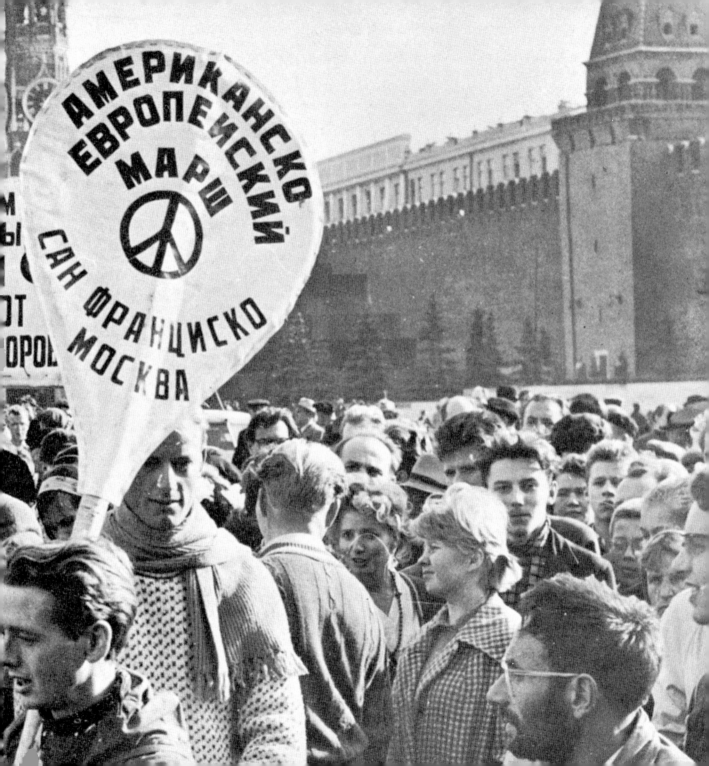

MOTHERHOOD FIGHTS FOR PEACE

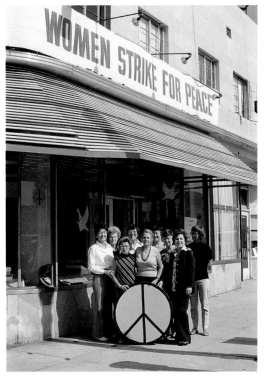

Women Strike for Peace
Activists from the Los Angeles chapter, ca 1970s.

ON THE OTHER HAND, Women Strike for Peace (WSP) presented an unassailable face to the world: motherhood. Who could argue with that?

Its members were moved to act not by the deployment of nuclear weapons, but by their detonation in the atmosphere. Saber rattling during the Soviets' erection of the Berlin Wall raised fears of the Cold War becoming altogether too hot. Dagmar Wilson, a Washington, D.C., homemaker and mother and one of the founders of Women Strike for Peace, feared that a shooting incident along Berlin's barricades could easily turn into nuclear war, through either accident or deliberate action.

Wilson conceived of organizing women during a meeting at her home with friends from the Committee for a Sane Nuclear Policy.

"It was a warm September night in 1961," she recalled. "We were worried. We were indignant. We were angry. . . . What [did it] matter who broke [the international moratorium] when everyone's children would fall victim to radioactive strontium 90? . . . Perhaps, we told ourselves that night, in the face of male 'logic,' which seemed to us utterly illogical, it was time for women to speak out."

Wilson's group, with urging from other activists, decided to go on strike. They issued a call for American women to walk away from their duties for a day. "We strike against death, desolation, destruction, and on behalf of life and liberty," said their appeal for volunteers. "Husbands or babysitters take over the home front. Bosses or substitutes take over our jobs!"

The women spread the message via phone calls, school and church groups, and other personal networks. The result: 50,000 joined a nationwide strike on November 1, 1961. About 800 women picketed the White House. The peace symbol had yet to play a visible role in their protests. In the months to come, however, WSP put its own spin on Holtom's design, using the peace symbol on a portion of the American flag, as well as a stylized dove, to identify their movement.

The group's antinuclear tactics expanded to include grassroots community action. Economic pressure began when WSP urged milk boycotts during atmospheric tests. Members left notes in empty bottles on their doorsteps, warning milk truck drivers they would cancel service unless milk supplies were immediately decontaminated. WSP members dramatized the danger of fallout for people of all ages by driving a wagonload of rotten vegetables through the streets of Philadelphia.

Electoral activism began in 1962, when WSP members supported many of the 20 candidates who ran for Congress on peace pledges. It culminated in 1970, when WSP member Bella Abzug, running on such a platform, won a congressional seat representing New York.

Nationally, the high point of the women's antinuclear movement occurred in September 1963, when dozens of WSP activists watched from the gallery as the United States Senate ratified an atmospheric test-ban treaty applying to the Soviet Union, Great Britain, and the U.S.

Among the mothers who sent telegrams of support to the WSP's push for a test-ban treaty was Coretta Scott King. The wife of civil rights leader Martin Luther King, Jr., she drew parallels between international and domestic affairs for the millions of African Americans still struggling with second-class citizenship and Jim Crow–style discrimination more than a century after the Civil War. "Peace among nations and peace in Birmingham, Alabama, cannot be separated," she contended. ☮

FLASHBACK: 1962

- Ken Kesey's *One Flew Over the Cuckoo's Nest* and Rachel Carson's *Silent Spring* are published
- The Cuban missile crisis ends when the U.S.S.R. agrees to remove missiles.

American Symbol
WSP button combines flag and peace.

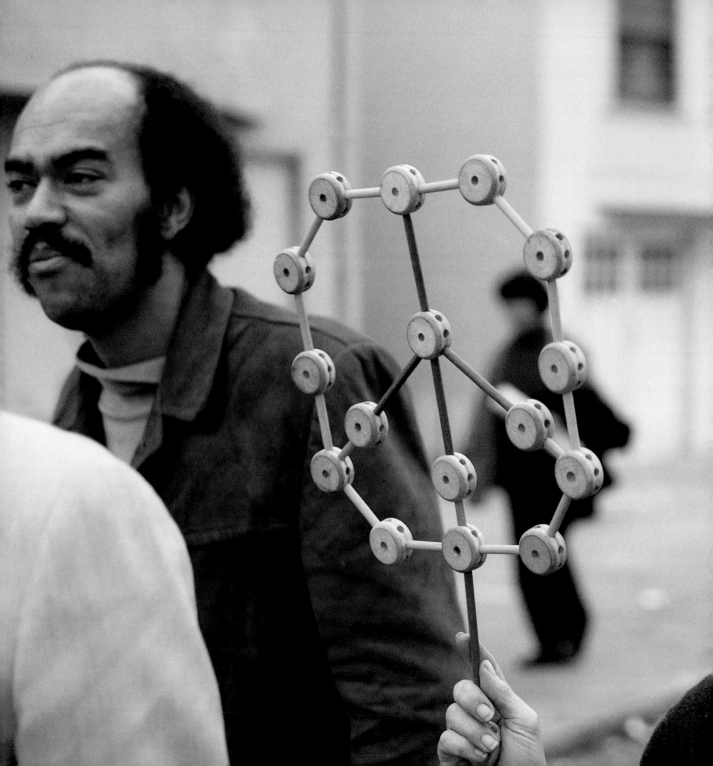

I've photographed many peace symbols in my life, but this one really made me smile. I don't know anything about this woman, but I assume she was a mother, perhaps borrowing her child's Tinkertoys to make this peace symbol for the march sponsored by the New Mobilization Committee in San Francisco in November 1969. The committee claimed that 250,000 protestors showed up to oppose the Vietnam War. The crowd was packed in tight, as they streamed into Golden Gate Park, walking and chanting, "What do we want?" "Peace!" "When do we want it?" "Now!" The *New York Times* reported that "people from many walks of life staged the biggest peace demonstration ever seen in the West. . . . While the most common style among the protesters was young, hippie and long-haired, there were also many older people. There were babies and small children all over the place in back packs, little red wagons, or strollers."

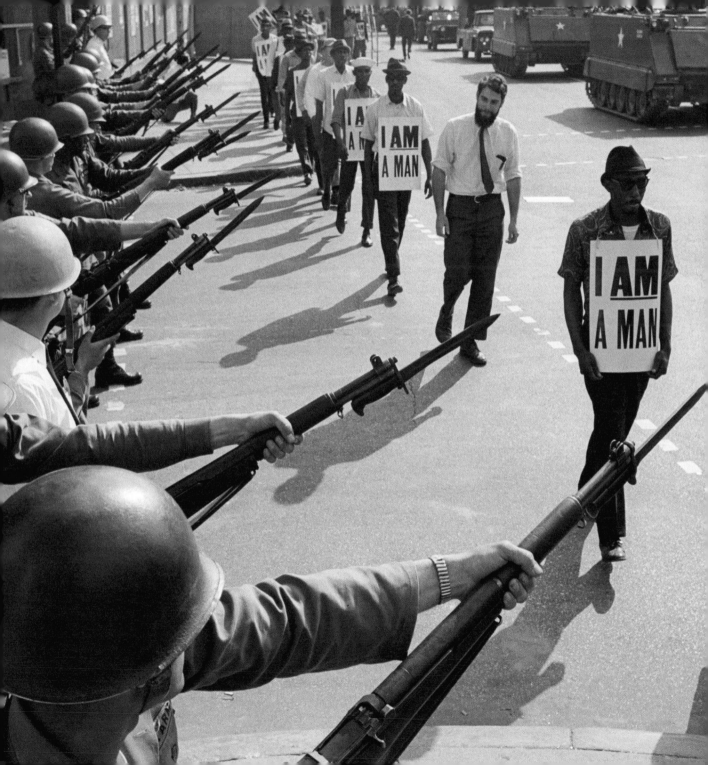

HOPES RISE for CIVIL RIGHTS

ONE MONTH BEFORE THE 1963 NUCLEAR TEST-BAN TREATY WAS RATIFIED, the nation's first massive civil rights gathering took place on the Washington Mall. Support for civil rights had been spreading since Martin Luther King, Jr., led a 1955-56 boycott that ended with the integration of the Montgomery, Alabama, public transit system. Freedom marches and lunch counter sit-ins followed, as black Americans demanded an end to racial segregation and political exclusion.

The call to the nation's capital brought 200,000 people to the grounds around the Washington Monument—the largest demonstration in American history at that time. King electrified the crowd with his "I Have a Dream" speech, laying out a vision of a harmonious American future that could be achieved through diligence, sacrifice, and peaceful progress.

[**"We must forever conduct our struggle on the high plane of dignity and discipline. "**]

Initially, King was reluctant to link peace and civil rights, believing that diverting attention from his primary goal of racial equality would weaken his impact. Later, as America expanded its war in Southeast Asia, King feared an ugly confrontation with a White House that had done more than any other in a century to promote civil rights.

The autumn following the Washington demonstration, the CNVA organized a racially integrated walk from Quebec to Cuba, with dual goals of peace and justice. Still, the demonstrators did not lose the focus that CNVA, the march's sponsor, had placed specifically on their march.

"We have been asked, 'Are you peace walkers or freedom walkers?'" the march's organizers said in a leaflet decorated with peace symbols. "We are both. The same belief makes us walk with signs calling for disarmament and with signs calling for 'Freedom Now.' We believe that all men, everywhere, are brothers." Despite that belief, in Georgia

Pride and Courage
Civil rights advocates march in Memphis in 1968.

I Have a Dream

(Opposite) Martin Luther King, Jr., waves to the crowd.

1964 Voting Rights Act

Law protects Americans' most basic right.

marchers were met with cattle prods and cell bars.

Northern students espousing a similar creed fanned out throughout Mississippi in 1964, hoping to register black voters and run "Freedom Schools." And in Alabama, in 1965, King organized a civil rights march from Selma to Montgomery. There too demonstrators were clubbed and cattle-prodded by white sheriff's deputies.

<div style="border:2px solid black; padding:10px;">

FLASHBACK: 1964

- Cassius Clay (Muhammad Ali) wins heavyweight boxing title.
- The Civil Rights Act of 1964 breaks new ground.
- Singer-songwriter Bob Dylan warns that "The Times They Are A–Changin.'"

</div>

A week after the violence, President Lyndon B. Johnson addressed Congress in support of a federal Voting Rights Act that had a rock-solid enforcement mechanism: federal protection at registration offices for anyone seeking to vote. At the end of his nationally televised address, Johnson concluded: "Their cause must be our cause, too. It is not just Negroes, but it is all of us who must overcome the crippling legacy of bigotry and injustice." He paused for just a moment, then dramatically quoted from folksinger Pete Seeger's song: "And we . . . shall . . . overcome."

Such a scene would have been unimaginable just a few years earlier. A Southern President had invoked the anthem of the civil rights movement to call for fundamental changes in America's race relations. The Voting Rights Act passed and was signed into law. The number of Southern African Americans registered to vote rose from a million in 1952 to three times as many by 1968. That represented 60 percent of potential black voters, the same as for registered whites. It was the high point of Johnson's Presidency, and perhaps the zenith of the civil rights movement.

Yet 1965 also planted the seeds of President Johnson's greatest frustration: Vietnam. ☮

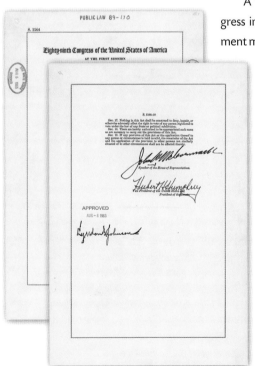

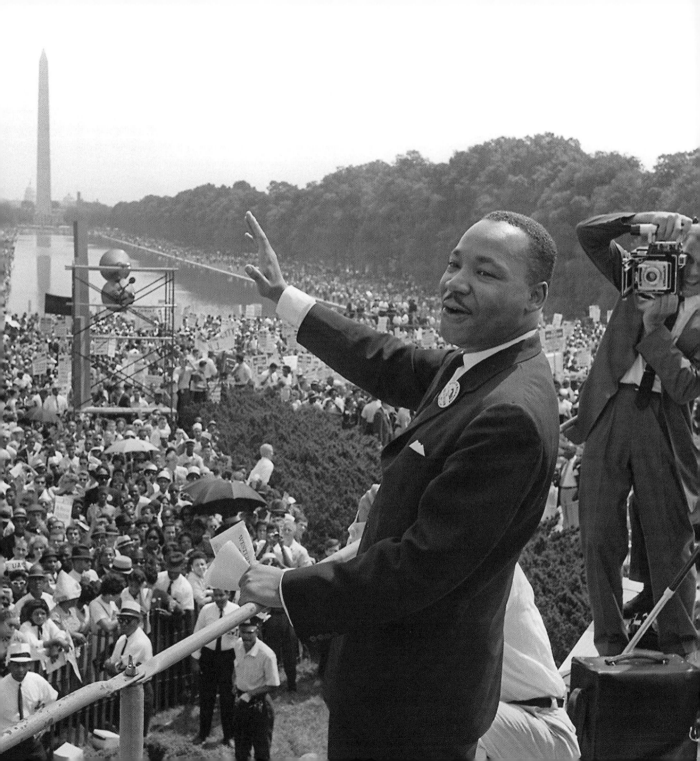

Folk Icon
Pete Seeger
strums his guitar
in spring 1963.

Pete Seeger

Singer-songwriter Pete Seeger used music to promote a better world. Critics assailed him for his minimalist musical style and his left-wing politics—he had been a member of the Communist Party in the 1940s, when a number of young American idealists had been attracted to what seemed to be communism's egalitarian philosophy. But when he sang and played, he defused tensions and spread good will. "This machine surrounds hate and forces it to surrender," he wrote around the edge of his banjo.

Seeger had an unlikely background for a liberal, itinerant folksinger. Born in 1919 into a wealthy New England family, he boarded at an elite prep school and attended Harvard

University with classmate John F. Kennedy. Introduced to folk music and the people who played it by his iconoclastic father, Seeger wandered the country during the late 1930s and early 1940s with Woody Guthrie and other musicians. He connected with poor and powerless people wherever he went, singing out for peace, labor unions, and human dignity.

Seeger performed in support of civil rights and participated, at the request of Martin Luther King, Jr., in the second, ultimately successful march from Selma to Montgomery, Alabama. He also sang at voter registration rallies for blacks in the South and during the Poor People's Campaign of 1968, which brought tens of thousands of protesters to the National Mall in Washington, D.C.

In 1961, Seeger marched in a New York City Easter demonstration sponsored by the Committee for a Sane Nuclear Policy. He visited North Vietnam near the end of the war, playing and singing for children on the streets of Hanoi. He promoted the cleanup of the Hudson River in the 1970s and sang at fund-raisers to raise bail money for nuclear power opponents arrested during demonstrations in the 1980s.

Yet his lasting contribution to peace was found in his music, not his deeds. Seeger wrote hundreds of easy-to-sing songs, some of which became anthems of the protest movements. Civil-rights advocates lifted their spirits by singing "We Shall Overcome," which Seeger adapted from a North Carolina gospel tune about persevering toward a brighter future. Opponents of the Vietnam War embraced Seeger's "Where Have All the Flowers Gone" and "Waist Deep in the Big Muddy." Critics of heavy-handed government sang "If I Had a Hammer," warning of danger abroad in the land.

The FBI, House Un-American Activities Committee, and various right-wing groups hounded Seeger for years, accusing him of working on behalf of communism long after he left the party. They scared off concert promoters and occasionally encouraged vigilante violence against Seeger and his friends.

But Seeger kept on believing in the power of his music. "Songs are sneaky things," he once said. "They can slip across borders. Proliferate in prisons. Penetrate hard shells." ☮

THE VIETNAM WAR
DIVIDES AMERICA

JOHNSON HAD WON OFFICE IN HIS OWN RIGHT IN 1964, though he first assumed the Presidency after Kennedy's 1963 assassination had propelled him into the highest office. LBJ ran partly on a platform of peace, painting his opponent, Barry Goldwater, as a trigger-happy hawk. "These are the stakes—to make a world in which all God's children can live, or to go into the dark," Johnson intoned in one of the most famous political television spots of American history. The camera showed a little girl picking daisy petals and counting to ten; a male voice then counted backward until reaching one. There followed a mushroom cloud and the boom of a nuclear explosion.

> "These are the stakes—to make a world in which all God's children can live."

Ironically, it was Johnson, not Goldwater, who plunged America into its longest war to date. U.S. strategic policy held that democratic nations fighting against communist takeovers anywhere in the world must receive military support. The autocratic South Vietnamese government hardly qualified as a democracy, yet its efforts to fend off the spread of communism from the north brought the American government to its aid.

To prop up the unpopular regime from internal and external threats, U.S. military advisers began arriving in the late 1950s. Their number, and the scope of their missions, slowly expanded. By the time Johnson inherited the Presidency, 16,000 Americans not only were assisting the South Vietnamese armed forces but also were joining in combat.

In 1964, Johnson parlayed a murky nighttime encounter off the coast of North Vietnam into an international incident, claiming American warships in Tonkin Bay had been attacked by torpedo boats. Although proof remained elusive, Johnson won congressional approval to wage open combat against South Vietnam's enemies. Bombing raids began early in 1965, accompanied by the first openly acknowledged combat troops: 3,500 marines to guard the air base at Da Nang. From that point, U.S. armed forces found them-

Back from Vietnam
(Opposite) Marines signal at ship's rail, 1969.

selves locked in a spiral of escalation. Troops on the ground invited attack by guerrilla forces. The Americans took casualties and retaliated. Enemy ranks swelled, with new recruits reacting to the violence perpetrated by superior American weapons. The guerrillas launched new attacks, attracting even more U.S. troop buildups and more combat.

America sent 200,000 troops to South Vietnam in 1965 and the same number the following year. The troop count peaked at 543,000 in 1969, without America being any closer to the goal of a stable, strong, and democratic South Vietnam.

As combat escalated, so did U.S. antiwar protests and the presence of the peace symbol. Pickets began popping up at nuclear disarmament rallies in the spring of 1963. Demonstrations spread to college campuses, and in April 1965 Students for a Democratic Society (SDS) sponsored the first major antiwar march and rally in Washington. Peace symbols appeared as pins on shirts and jackets of the neatly dressed demonstrators.

Reasons for joining protests varied. Some Americans objected to the involvement in Vietnam on legal grounds, because Johnson had acted without an official declaration of war. Others protested over moral issues, particularly the high civilian casualty rate and the use of napalm, a jellied explosive that incinerated victims. Some

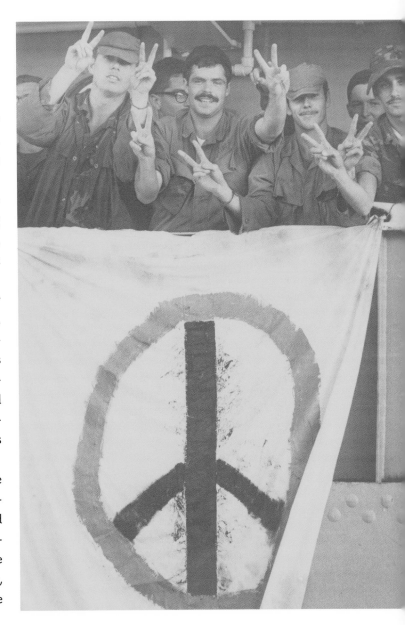

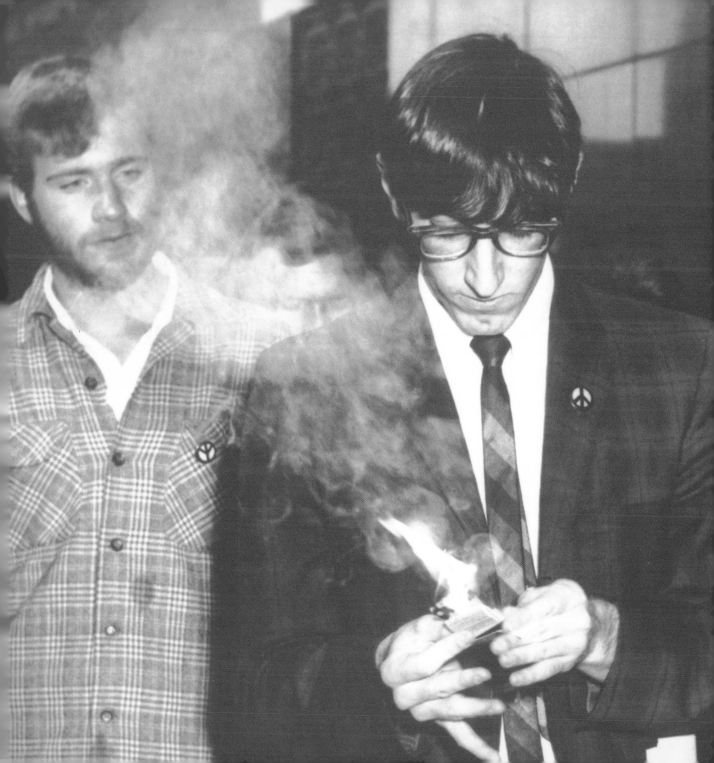

argued that the potential fall of South Vietnam to communism posed little risk to America's national security, and thus should be ignored.

As news coverage revealed more about the corrupt leaders of South Vietnam and the difficulties of waging war against guerrillas known as Vietcong, more protesters, including soldiers who had returned from their tours overseas, protested both strategy and tactics. Three pacifists—a Quaker, an 82-year-old refugee from Nazi Germany living in Detroit, and a volunteer in the Catholic Worker Movement (an altruistic and activist organization founded in 1930) —incinerated themselves in 1965 to draw dramatic attention to the war. A 22-year-old Catholic pacifist, David Miller, burned his draft card at a New York induction center. He was the first to do so after Congress declared such destruction illegal.

Two weeks after Miller burned his card, protesters staged a mass burning in New York's Union Square. "What we are saying," a 1965 CNVA flier said beneath a peace symbol, "is . . . the real crime is not burning this scrap of paper; the real crime is burning villages, burning hospitals, burning children."

A limited, peacetime draft had continued after the Korean War ended in 1953 but had expanded with America's military commitment to South Vietnam. Local draft boards initially determined who would serve. At the 1969 height of the war's demand for American manpower, Congress reinstated the lottery used in World War II, assigning numbers randomly to each of 366 possible birthdays. Men with low birthday draft numbers—September 14 was No. 1—had a much higher chance of serving for two years in ground combat. The draft loomed over young men until its suspension at war's end in 1973.

In the mid-1960s, two brothers, Daniel and Phillip Berrigan, became heroes of the antiwar movement through their nonviolent protests. Both were Catholic priests, though Phillip left the priesthood after he secretly married a fellow activist. In 1967 Phillip and three other protesters were catapulted into the public spotlight when they poured human blood—their own—on

> "the real crime is not burning this scrap of paper; the real crime is **burning villages, burning hospitals, burning children."**

Up in Smoke
(Opposite) Robert Talmanson, age 19, burns his draft card, 1966.

Selective Service records in the Baltimore Customs House. "This sacrificial and constructive act is meant to protest the pitiful waste of American and Vietnamese blood in Indochina," Phillip declared. Arrested for civil disobedience, he was sentenced to six years in prison but released on probation after several months.

FLASHBACK: 1965

■ Ralph Nader publishes *Unsafe at Any Speed: The Designed-In Dangers of the American Automobile.*

■ Cesar Chavez takes National Farm Workers Association out on strike.

The following year, he and his brother, Daniel, along with seven other Catholic activitists, gained fame as the Catonsville Nine, when they poured homemade napalm—the incendiary agent favored by the U.S. military in Vietnam—on some 300 draft files from the Catonsville, Maryland, draft board. For this act, both brothers spent several years in prison, but that did not deter them. They kept up their protesting and went on to establish the Plowshares Movement, whose actions against nuclear weapons again landed them in prison.

The antiwar magazine *WIN*, which called itself "the liveliest publication ever to come somersaulting out of the peace movement," took its own nonviolent, but humorous, tack to protesting in 1966. Its editors made plans to enter the New London, Connecticut, nuclear submarine base—site of the original Polaris Action protests—and paint one of the boats a cheerful canary yellow, echoing the Beatles' song "Yellow Submarine." Then, they changed their minds in favor of an action less likely to incite violence. They built a 12-foot-long sub out of canvas and painted it yellow, decking it out with a peace symbol on its miniature conning tower. They marched through Manhattan to the Hudson River for a ceremonial launch of their peace vessel. "We learned how to make cops grin back that day," *WIN* reported, "and how to make spectators feel something besides anger or guilt."

Still, direct confrontation continued. Jan Barry decided to organize Vietnam Veterans Against the War. He said America had sent its troops to South Vietnam to "act as the palace guard in this police state." He had served in South Vietnam and entered West Point on his return, despite likening America's presence in Southeast Asia to the British Imperial Army in India. But he did not stay at West Point long. He dropped out to oppose the war.

Underground GI newspapers with names like *Fed Up!, Short Times,* and *Last Harass* sprang up at military bases around the country. They published articles and opinions critical of the

war, often illustrated with peace symbols. They also printed basic information about the rights of soldiers who opposed service in Vietnam. Editor Roger Priest was court-martialed for publishing the antiwar paper *OM—The Serviceman's Newsletter*. His accusers said he published "statements advising and urging insubordination, disloyalty and refusal of duty." He was convicted and given a bad-conduct discharge.

People outside the military stepped up to interfere with the government's induction of draftees. Students for a Democratic Society and other groups tried to halt the flow of young men into the armed forces. During a national "Stop the Draft Week" in October 1967, nonviolent protesters lay down in front of the gates of the induction center in Oakland, California, leading to 124 arrests on the first day. A few women also used a tactic as ancient as Aristophanes' *Lysistrata*: "Women say yes to men who say no," read their signs.

Women Strike for Peace was also at the gates in Oakland, having found new life in the antiwar movement. Its recruiting letter to Bay Area women, asking them to help walk the weekly picket line outside the induction center, described their reception by the draftees. "We know that we are effective because we can see it; we often escort young men directly from the busses. . . . to be counseled before they enter the induction center—this in spite of the attempts by induction officials to herd them quickly into the building. We are often thanked for being there. We are even told we are beautiful."

At the other end of the continent, at a free counseling center on Long Island, WSP volunteers worked tirelessly five days and nights each week, often staying until early in the

Pen vs. Sword
GIs voice opinion in underground paper.

Pentagon Protest
(Following pages) George Harris sticks flowers in guns, 1967.

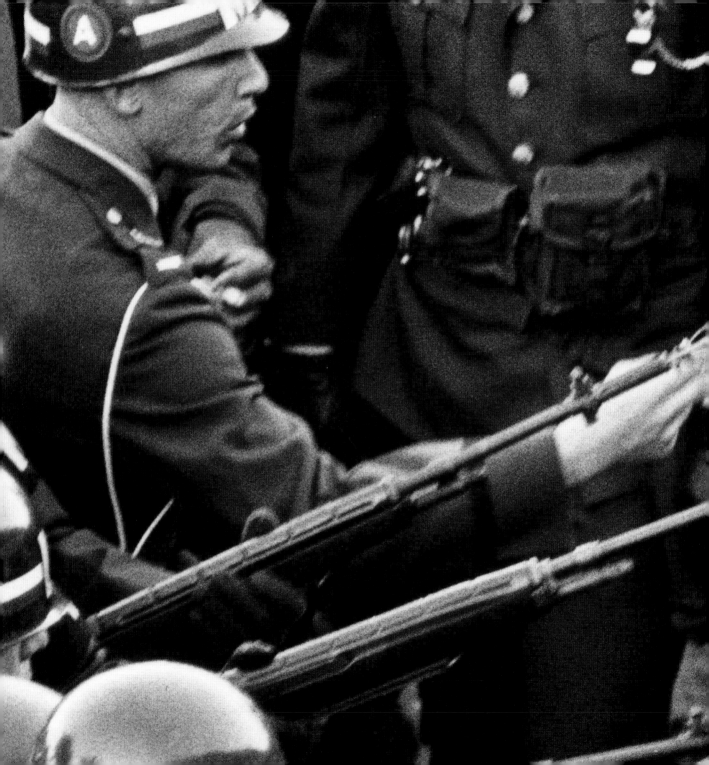

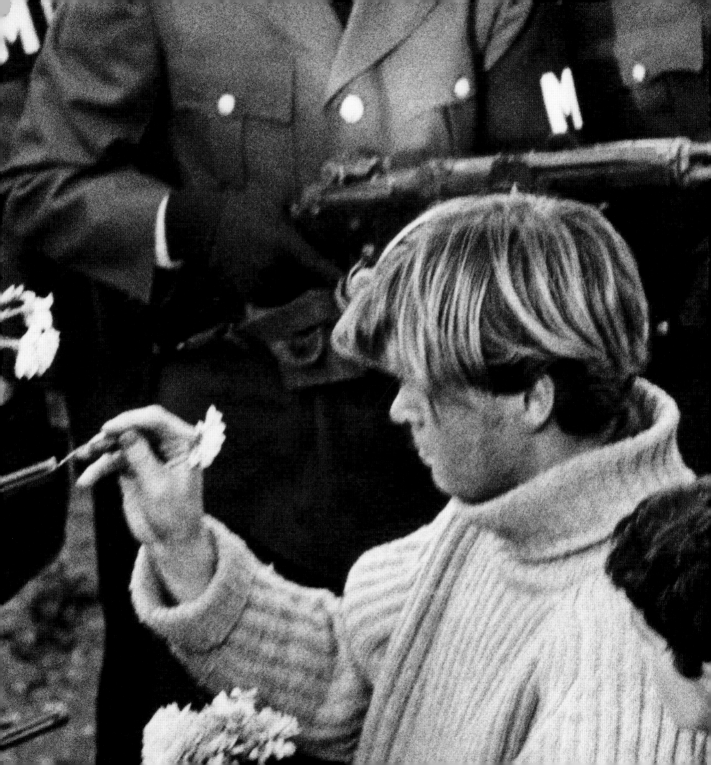

morning to help draftees who didn't want to fight. The most public figure sentenced to prison for counseling draft evaders was Dr. Benjamin Spock, author of a best-selling book on how to raise children effectively. The U.S. government formally accused nearly 210,000 men with violating draft laws; 4,000 went to jail. According to the best estimates, 100,000 "draft dodgers" fled the country, with perhaps 90 percent going to Canada.

College students by the million took up the cause of the Vietnam War. At Columbia University in New York, Students for a Democratic Society led a demonstration in 1968, protesting the university's relationship with the Institute for Defense Analysis and the construction of a gym that would displace black and Hispanic neighbors. Sit-ins occupied four buildings. The protest led to hundreds of arrests and ultimately to the resignation of the university president. Protests quickly spread to other campuses.

By the late 1960s, many of the soldiers on the ground in Southeast Asia openly protested the war. Military officers tried to ban soldiers from wearing or displaying the peace symbol and other antiwar statements. At first, the military cracked down on offenders, but that ultimately proved ineffective. During the huge demonstrations of Moratorium Day in October 1969, some soldiers on duty in South Vietnam wore black armbands, some with the peace symbol, in a show of support. One journalist in the field near Da Nang stumbled upon a platoon where half the men wore their protests on their sleeves. Creative marines in South Vietnam made olive-drab peace symbol pins by twisting one grenade ring and two cotter pins into the familiar circle shape.

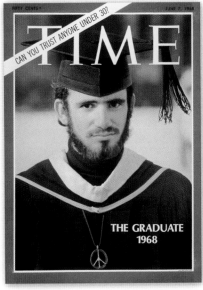

THE GRADUATE
1968

Time Cover
UCLA grad invokes tenor of the times.

Dr. Benjamin Spock
(Opposite) Baby expert works against draft.

Some military officers and conservative civilians tried to brand such soldiers "communists" for opposing their country's war. A GI letter-writer in Alaska told *Playboy* magazine of a friend's imprisonment for refusing to remove a black armband. "I think General [Creighton] Abrams once remarked, about troops in Vietnam who wore armbands, 'I don't care what they wear as long as they do their job.' And at Fort Lewis, Washington, thousands of men wore these armbands. . . . But in a place as remote as this, the brass make their own rules and to display a peace sign is to be charged with being a Commie. We've also been told that wearing a peace medallion is considered carrying a concealed weapon and that the [military police] would act accordingly." ☮

Victory at School
Mary Beth and John Tinker display armbands.

Tinker Case

MARY BETH TINKER was just another eighth-grader at Warren Harding, Jr. High School in Des Moines, Iowa. But when she, her brother, John, and their friend Christopher Eckhardt put on black armbands sporting a white peace symbol, they rang a freedom bell that echoed all the way to the Supreme Court.

Christopher and his mother had joined a November 1965 march from the White House to the Washington Monument in protest of the Vietnam War. On the ride home, the Eckhardts and about 50 others debated how to spread their ideas. They settled on urging students to wear armbands to support a halt in American bombing raids.

Mary Beth, John, and Christopher agreed to put their sentiments on their sleeves. They said the symbolic act expressed not disapproval of war as much as sorrow for the deaths on both sides. They favored peace—and life.

School administrators learned of the plan and banned the armbands. A few students wore them anyway, and John and Christopher, both at Roosevelt High School, were quickly suspended. Mary Beth wore her armband through the lunch hour before being called to the office and asked to remove it. Even though she did so, the school suspended her.

The Eckhardt and Tinker families filed suit. Lower courts ruled against them, but in February 1969, the Supreme Court issued a ruling in *Tinker* v. *Des Moines Independent Community School District*, deciding seven to two in the students' favor. Justice Abe Fortas's majority opinion likened the students' actions to pure speech, though a circle and three lines conveyed no words. "It can hardly be argued," he wrote, "that either students or teachers shed their constitutional rights to freedom of expression at the schoolhouse gate."

In the next decade the peace symbol figured in several notable legal and administrative decisions, including two in 1970. In one the Second U.S. Court of Appeals ruled that the First Amendment protected the rights of Women Strike for Peace to use buttons and decals displaying the peace symbol superimposed on the American flag. In the other the U.S. Patent Office rejected applications by two different companies to trademark the peace symbol, thus placing the symbol firmly in the public domain. Then, in 1973, the New Jersey Supreme Court threw out the conviction of Stanley Zimmelman, who decorated his ice cream truck with an image of a peace symbol atop an American flag. The court said the state's law banning graphics on a flag was unconstitutional. The following year, the U.S. Supreme Court reversed the conviction of Harold Spence, a college student who had hung an American flag outside his apartment with a peace symbol taped to it. He had been convicted of improper use of the flag. "A person gets from a symbol the meaning he puts into it," wrote Justice Harry Blackmun, "and what is one man's comfort and inspiration is another man's jest and scorn." ☮

SEEDS of LIBERATION TAKE ROOT

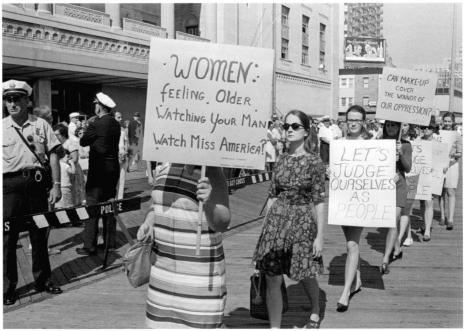

Miss America 1968
Protesters target Atlantic City pageant.

OPPOSITION TO THE WAR IN VIETNAM branched out in surprising ways, giving life to movements empowering women, the poor, and racial minorities. An entire generation of Americans had begun to examine the validity of the war, and in so doing, they began to question other well-established norms. Although women's rights had been an explicit manifesto since at least 1848, the flowering of popular activism in the 1960s invigorated the movement with new power. Female activists serving in Mississippi in 1964 at a "Freedom House"—a sort of civil rights headquarters, office, and dormitory—went on strike for equal treatment. They complained that the men working for civil rights during that long, hot summer wanted the women volunteers to serve as domestic help, cooking and cleaning while the men drove the back roads organizing potential voters. Hundreds marched during an antiwar demonstration in 1968 to

bury "Traditional Womanhood" in Arlington National Cemetery. Americans began to hear talk of a new movement, Women's Liberation. The movement made front-page news in September 1968 when 400 protesters disrupted the Miss America Pageant, claiming it reduced women to sex objects. Some tossed brassieres into a "freedom trashcan," sparking the myth of widespread bra-burning in the late 1960s.

The Vietnam War injected itself into America's racial tensions as well. Black Americans fought in disproportionately high numbers. Many questioned what was in the war for them. "I ain't got nothing against them Viet Cong," heavyweight boxing champion Muhammad Ali announced as he refused induction in 1967. An all-white jury convicted him of draft evasion despite his claim of exemption as a Muslim minister. The Supreme Court threw out Ali's fines and jail time after agreeing he should have been legally classified as a conscientious objector. While appealing his criminal conviction, he was stripped of his boxing license. Fighting to stay out of what he called "the white man's war" kept him out of the ring for three and a half years during his athletic prime. Elsewhere, black Americans who previously had used the slogan "War isn't our thing" began participating in antiwar demonstrations in larger numbers.

Martin Luther King, Jr., decided to come out publicly against the Vietnam War in December 1966, after President Johnson proposed shifting money from social programs to the military budget. In a series of speeches, King made the explicit connection between the war and such social problems as unemployment and racial inequities. People living in poverty "are paying a double price of smashed hopes at home and death and corruption in Vietnam," he told a church group in New York. In another speech, shortly before his assassination in April 1968, he added, "It's inevitable that we've got to bring out the question of the tragic mix-up of priorities. We are spending all of this money for death and

Muhammad Ali
Champ, training in 1966, refuses induction.

"I ain't got nothing against them Viet Cong."

destruction, and not nearly enough money for life and constructive development. . . . When the guns of war become a national obsession, social needs inevitably suffer."

Fueled by unemployment and injustice, race riots burned America's urban ghettos each summer from 1965 through 1968. America's poor turned to directly challenging the power brokers in Washington, D.C., by building "Resurrection City" in the summer of 1968. At the time of his death, King had been planning the huge encampment on the Washington Mall to focus national attention on poverty. The crowd that answered his call mirrored the triumphant civil rights gathering that had occurred five years earlier, but this conclave looked quite different. A wet spring had churned up a sea of mud and unleashed armadas of mosquitoes. Hastily constructed plywood lean-tos sagged and leaked.

> ## FLASHBACK: 1966
>
> ■ *Star Trek* makes its TV debut.
> ■ Betty Friedan and others create the National Organization for Women (NOW).
> ■ Jefferson Airplane and Big Brother & the Holding Company perform at the Fillmore.

Some shanty builders painted peace symbols and slogans on the outer walls. "Jobs, Not Genocide" read one, next to a peace symbol. The walls of the shack next door proclaimed, "War. Poverty. Hate. The American Dream," followed by "Hell No, We Won't Go." Holtom's design filled the "O" in "No."

The assassinations of King and Democratic presidential candidate Robert F. Kennedy that spring contributed to a sense of desperation, as did the government's threats to bulldoze the flimsy shacks. Pete Seeger sang folk songs to keep spirits up. But after he left, bulldozers and a phalanx of arresting officers had the last word.

Events of early 1968 prompted President Johnson to throw in the towel. A well-planned, nationwide counterattack by the Vietcong during the Tet holiday that winter dampened talk of the war being over soon—and even of its being winnable. Antiwar candidate Eugene McCarthy, who became the rallying point for counterculture forces that opposed Johnson, nearly won the first presidential primary. Johnson declined to run for reelection and took the first steps to reduce the size of the American fighting force in Southeast Asia. The quagmire in Vietnam had proved unsolvable, while drawing money and attention away from the President's beloved "Great Society" of domestic programs.

"The evidence from the Pentagon Papers is clear," Howard Zinn declared in his *People's*

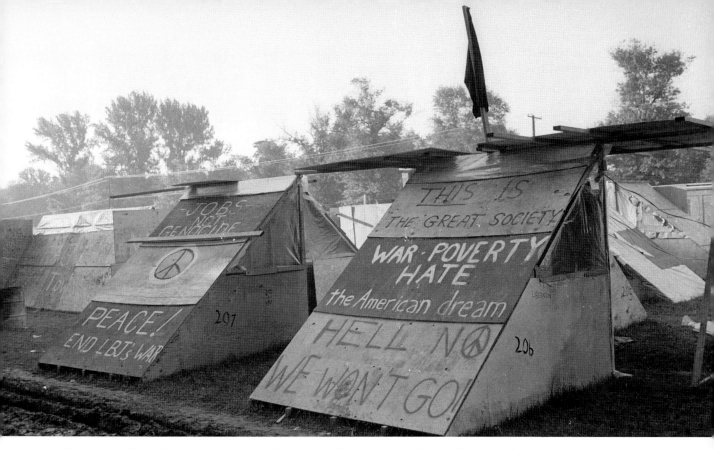

History of the United States. Johnson's decision in 1968 "to slow down for the first time the escalation of the war, to diminish the bombing, to go to the conference table, was influenced to a great extent by the actions Americans had taken in demonstrating their opposition to the war." Peace had beaten war.

Activists also changed how millions of young Americans looked at the world. Pacifists had hammered away for years on the theme of ordinary people cutting ties to the war and the industries that supported it. They also had raised suspicions about trusting government. In a world where seemingly everything could be considered suspect, many young Americans opted out. Following the exhortation of former Harvard professor Timothy Leary, they turned on, tuned in, and dropped out. Gone were their parents' codes of dress, decorum, and sexual conduct. ☮

Shanties
Resurrection City residents express frustration, despair.

THE COUNTERCULTURE SEEKS ITS OWN PATH

TO BE A HIPPIE, as the rebellious youths were called, was to be anything you wanted to be, provided it didn't hurt anyone. The pillars of hippie lifestyle emerged in the mid-1960s. The first was nonmaterialism. Hippies rejected their parents' jobs in office buildings and homes in the suburbs in favor of shared property, an emphasis on spiritual growth over material accumulation, health foods, and sometimes communal living. Second was psychedelic rock music, played by bands like The Grateful Dead, Jefferson Airplane, The Doors, and Big Brother & the Holding Company. Third was "free love," a wide-ranging sexual revolution unencumbered by marriage and fueled by the introduction of the birth-control pill in 1960. And fourth was the drug culture, which moved beyond the marijuana of the 1950s Beat Generation to embrace a new variety of drugs. They included lysergic acid diethylamide, a hallucinogen known as LSD or "acid." A Swiss chemist developed the drug in 1938, and the CIA began putting it to the test in San Francisco in the 1950s to investigate its potential as a mind-control drug. Some test subjects received the drug voluntarily, some without their knowledge. By the time LSD proved its ineffectiveness as a tool for American spymasters, thousands of Americans had taken their first mind-expanding journeys, courtesy of the U.S. government.

The San Francisco Bay Area had plenty of LSD, a large hippie population, and most of the best rock bands in the

Peace Fashion
Woman models dress and glasses, 1967.

Acid Test
(Opposite) Tom Wolfe's book chronicles LSD culture.

Message in a Circle
(Following pages) Peace sentiments in many varieties

country, making it the heart of the counterculture. Underground chemist Augustus Owsley Stanley III—known to all as just Owsley—produced the homemade, high-grade LSD that initiated thousands of people into their first surreal, mind-expanding experiences. So-called acid tests—"Can you pass the acid test?" the fliers asked—brought hundreds of counterculture youths together in the Bay Area in the mid-sixties, before California finally declared the drug illegal in October 1966.

Ken Kesey, one of the acid-test organizers, took the drug counterculture on the road from California to New York in a garishly painted bus whose destination sign initially read "Furthur." That was always the goal, to take the mind further than it had ever gone. But as Tom Wolfe documented in *The Electric Kool-Aid Acid Test*, his account of Kesey's wanderings, the trip often took strange twists and turns. "Sandy takes LSD and the lime ::::::: light ::::::: and the magical bower turns into . . . neon dust . . . pointillist particles for sure, now," Wolfe wrote in attempting to map the journey of a drugged-out mind. "Golden particles, brilliant forest-green particles, each one picking up the light, and all shimmering and flowering like an electronic mosaic, pure California neon dust."

The description fit the creative spirit of the age as well. Artists portrayed the words and symbols of "peace" and "love" on posters featuring swirls and loops of primary colors. Embraced by the counterculture but always poking fun at it, San Francisco artist Robert Crumb, a former greeting card designer, created alternative comics featuring Mr. Natural, Fritz the Cat, and other characters. His "Keep on Truckin' " poster became a staple of college dormitories, along with peace symbol posters and drug paraphernalia.

FLASHBACK: 1967

■ *Rolling Stone* magazine is launched by 20-year-old Jann Wenner.

■ The Beatles release their *Sgt. Pepper's Lonely Hearts Club Band* album.

■ U.S. sends troops to the Cambodian border.

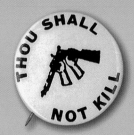
THOU SHALL NOT KILL

Question Authority

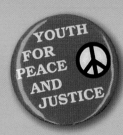
YOUTH FOR PEACE AND JUSTICE

DROP IT

NO NUKES

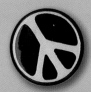

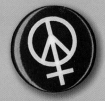

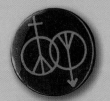

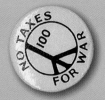
NO TAXES 100 FOR WAR

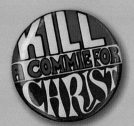
KILL A COMMIE FOR CHRIST

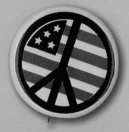

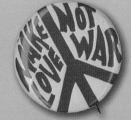
MAKE LOVE NOT WAR

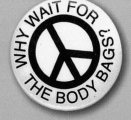
WHY WAIT FOR THE BODY BAGS?

WSP

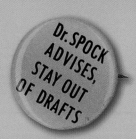
Dr. SPOCK ADVISES, STAY OUT OF DRAFTS

VIETNAM LOVE IT OR LEAVE IT

WSP

ANOTHER PATRIOT
FOR PEACE

Make Love
Not War

POOH FOR
PEACE

WATTS
PEACE IS
BLACK AND WHITE
CALIFORNIA

WHEN
YOU'VE SEEN
ONE ATOMIC WAR
YOU'VE SEEN
THEM ALL

NO WAR

BREAD
NOT
BOMBS

THE CONTINENTAL WALK

CND

McGOVERN

PREPARE
FOR
PEACE
NOT WAR

Resist the Draft
Stop the Arms
Race

BACK BY
POPULAR DEMAND

END

Human Be-In
1967 poster promotes seminal Bay Area event.

Janis Joplin
(Opposite) Performer electrifies Monterey Pop crowd.

In January 1967 the first Human Be-In was held at Golden Gate Park in San Francisco. That countercultural gathering of 200,000 set the stage for the zenith of the hippie movement during the following "summer of love." Speakers included Timothy Leary, poet Allen Ginsberg, and comedian Dick Gregory. Owsley supplied the acid while the Dead, Quicksilver Messenger Service, and Jefferson Airplane supplied the music. The alternative *Berkeley Barb* hailed the triumph of peace. The gathering produced "no anger, no reproach for the act of nonlove. . . . All seemed filled, contented and giving," the paper said.

"**The key ethical element in the hippie movement is love.**"

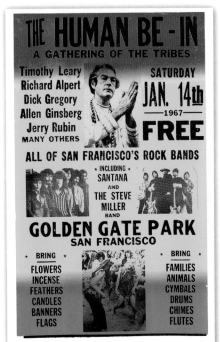

THE HUMAN BE-IN
A GATHERING OF THE TRIBES

Timothy Leary
Richard Alpert
Dick Gregory
Allen Ginsberg
Jerry Rubin
MANY OTHERS

SATURDAY
JAN. 14th
—1967—
FREE

ALL OF SAN FRANCISCO'S ROCK BANDS

* INCLUDING *
SANTANA
AND
THE STEVE MILLER BAND

GOLDEN GATE PARK
SAN FRANCISCO

* BRING *
FLOWERS
INCENSE
FEATHERS
CANDLES
BANNERS
FLAGS

* BRING *
FAMILIES
ANIMALS
CYMBALS
DRUMS
CHIMES
FLUTES

The hippie music scene exploded that summer at the Monterey Pop Festival, the prototype for all subsequent megarock concerts. The Jimi Hendrix Experience had its American debut at Monterey and Janis Joplin gave perhaps her greatest performance. Themes of love and peace washed over the crowd. *Time* magazine, noting how often the counterculture used the word "love," declared in a 1967 cover story, "The key ethical element in the hippie movement is love—indiscriminate and all-embracing, fluid and changeable, directed at friend and foe alike."

The Diggers, a San Francisco-based organization, married love with a system of distribution and a flair for drama. They announced their intention to help young people find their creative potential. Along the way, the Diggers ran free stores and provided wandering kids with a place to crash. They gave away tons of free food on the streets and in the festivals of San Francisco. The Diggers also practiced what they preached about creativity, performing a lively brand of street theater. In one notable performance, they walked down Haight Street while wearing five-foot-high animal masks, carrying a coffin, and declaring "The Death of Money and the Birth of the Free." ☮

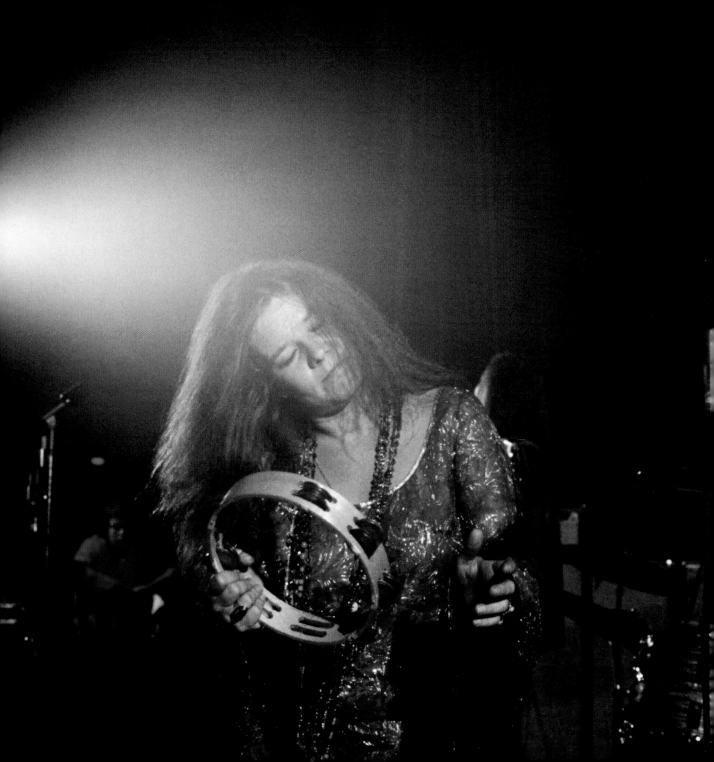

One weekend in 1969

we packed our two kids into our light blue Volkswagen and headed north to San Francisco. The city was alive with posters, peace symbols, graffiti, and richly colored VW "bugs" and buses (often packed with long-haired young people). Even Fords and Chevys featured handmade signs and bumper stickers proclaiming "Make Love, Not War" and "Vietnam . . . Love it or Leave it." (Gerald Holtom, the creator of the peace symbol, had displayed his symbol on a long banner atop his VW bus back in 1958.) Twice that memorable day in 1969, we saw this dazzling VW, its exterior a swirl of the owner's artistic flowers, stars, and a LeRoy Jones poem. That same year, Canada Dry sponsored a "Paint Your Wagon" contest to promote one of its soft drinks. Contestants were asked to decorate their ideal Volkswagen on the entry form. The company was deluged with 35,000 entries, many decorated with peace symbols. None of the five winning entries displayed the peace symbol.

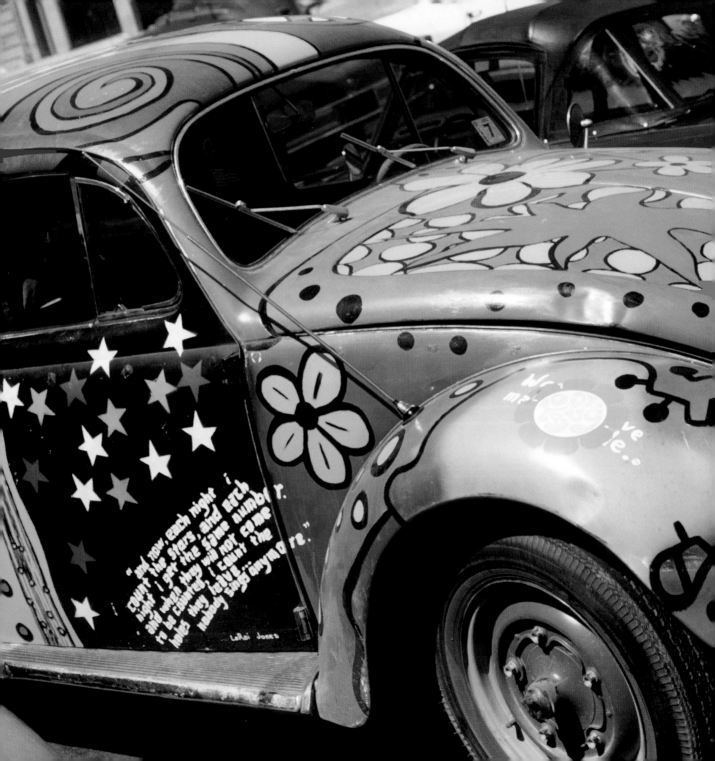

"and now, each night i count the stars, and each night i get the same number. and when they will not come to be counted, i count the holes they leave.

nobody sings anymore."

LeRoi Jones

ENTER
ABBIE HOFFMAN

WATCHING FROM THE EAST COAST with a gleam in his eye, Abbie Hoffman took note of the news media attention the Diggers brought to themselves and their causes. Hoffman, raised in a New England Jewish family, received a master's degree in psychology from the University of California and displayed a talent for messing with the minds of authorities. Taking a cue from the Diggers, he opened a free store in New York's Lower East Side. He called himself an anarchist and urged people to reject the establishment and to try to live without money.

Along with Jerry Rubin, he formed the Yippies. They saw the potential for pure joy in tweaking the nose of the establishment.

FLASHBACK: 1968

- ■ The musical *Hair* opens on Broadway.
- ■ Presidential contender Robert Kennedy is assassinated.
- ■ Richard Nixon is elected President.

Hoffman devised a series of theatrical "media events" to dramatize what he saw as the faults of buttoned-down America. He dropped paper currency on the floor of the New York Stock Exchange and watched the tickers stop dead as brokers scrambled to snap up the greenbacks. He mailed marijuana joints to 3,000 people selected at random out of a phone book. Perhaps his greatest stunt was to attempt to levitate the Pentagon during an antiwar rally in October 1967. "Yippies believe in the violation of every law, including the law of gravity," he once said.

In 1968 Hoffman pledged to disrupt the Democratic Party's national convention in Chicago. He played to the news media by threatening to paint the Yippies' cars yellow. Arriving delegates would think they were taxis and get taken for an unexpected ride, he said.

Abbie Hoffman, Timothy Leary, Jerry Rubin Trio reveal plan to disrupt '68 convention.

The Yippies had a relatively small impact on the convention. They attracted cameras outside the convention hall when they produced a hog named Pigasus and nominated him for President. But that was nothing compared with the televised rioting in the streets of Chicago as thousands of antiwar protesters clashed with police. Public reaction to the convention's chaos undermined the chance of nominee Hubert Humphrey to win the Presidency that November. ☮

Art and Music
Posters promote bands at the Fillmore (right), while partygoers celebrate its first anniversary (below).

Fillmore West

I N 1966, SAN FRANCISCO MERCHANTS didn't want anything to do with the posters promoting concerts at that strange new nightclub, the Fillmore. The posters' colors blared like discordant music, their letters swirled and dripped almost indecipherably, and their tone clashed with the mood of conservative capitalism. But they spoke to young people. The artwork advertised new forms of psychedelic music, and visually suggested the entire experience of a rock concert, including drugs and sexual energy.

The posters sprang up as if by magic. San Francisco promoter Bill Graham put out fliers in November 1965 to advertise fund-raising parties for the San Francisco Mime Troupe. The fund-raisers' success convinced him to try for bigger things. He eventually

got a permanent dance hall permit for the Fillmore, a 50-year-old dance hall. Graham's first concert there featured Jefferson Airplane. The promotional poster was tame, but within weeks, a group of artists began churning out posters unlike anything seen before. The bands they advertised included not only top psychedelic rock acts, such as the Grateful Dead, but also blues stars such as Muddy Waters and B.B. King.

The Fillmore became the place to go, a quirky, low-key venue where patrons could dance, get high, and pick an apple from the barrel marked "Take One or Two." In 1968, Graham opened a second hall in New York City. He christened his two venues Fillmore West and Fillmore East.

For five years, artists including Wes Wilson, Alton Kelley, Rick Griffin, and Bonnie MacLean distilled the counterculture into graphic design in return for rent money. Their style deliberately turned the solid, easy-to-read graphic art of the 1950s on its head. Subjects included surreal landscapes, distorted body parts, and a variety of peace symbols, all squeezed into an organic brickwork of words. Poster production continued until Graham closed the two Fillmores in 1971.

WOODSTOCK NATION

Woodstock Stars
Jimi Hendrix, below; Roger Daltrey of The Who, opposite

DESPITE THE VIOLENCE OF CHICAGO, the culture of peace lived on. The counterculture, ever under the banner of the peace symbol, gave flowers, free love, drugs, and electric guitars another try in August 1969 at the Woodstock Aquarian Music and Art Fair in upstate New York. Organizers planned to have "three days of peace and music" at Max Yasgur's dairy farm. Instead of the 50,000 or so they expected to attend each of the three days of the festival, they got nearly 500,000. Traffic backed up for 15 miles, as hippies streamed toward a place where they hoped to live, if only for a while, by their own rules.

Sanitation, food, medicine, and trash became immediate problems. Rain turned the grounds into a quagmire. Three people died and two were born in a temporary encampment that briefly became New York's third largest city.

Most musical acts gave less than their best performances. Country Joe and the Fish roused the crowd with "Fixin' to Die Rag," as did Arlo Guthrie's ode to drug smuggling, "Coming Into Los Angeles." Headliners included the Grateful Dead, The Who, Sly and the Family Stone, and Jimi Hendrix. Ironically, the mood was best captured by one who wasn't there. Canadian-born songwriter Joni Mitchell's classic "Woodstock" ballad celebrated people trying to set their souls free and find the simplicity of Eden.

It was a plea for a return to a time without hatred and violence. A time, in short, embodying all that the peace symbol had come to stand for. Although the reality of Woodstock was never paradise on Earth, it became a form of shorthand for a generation that came of age amid all of the terrors of war and the nuclear age—and the delights of the sixties. ☮

FLASHBACK: 1969

- James Earl Ray is sentenced to 99 years for the assassination of Martin Luther King, Jr.
- The draft lottery is instituted, resulting in massive demonstrations.
- U.S. astronauts land on moon.

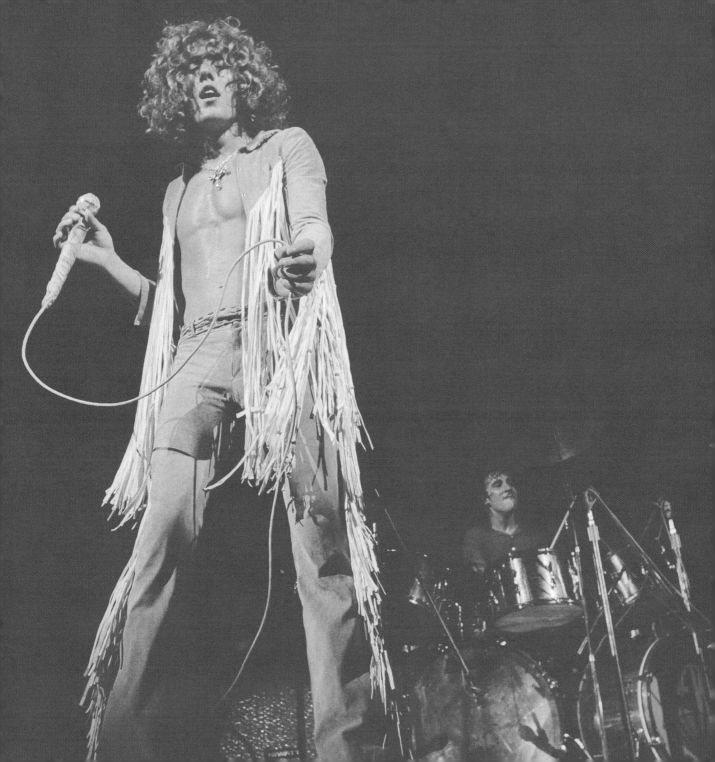

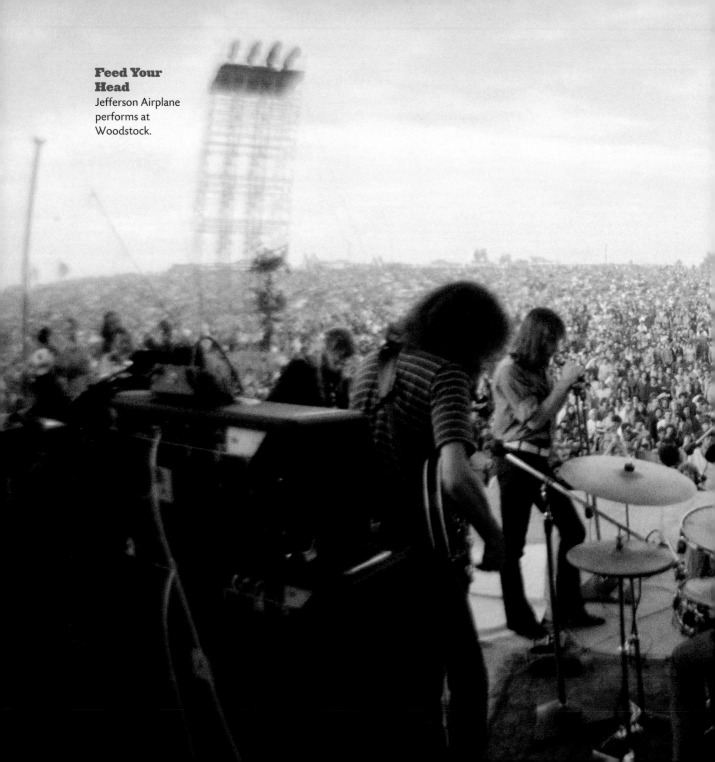

Feed Your Head
Jefferson Airplane performs at Woodstock.

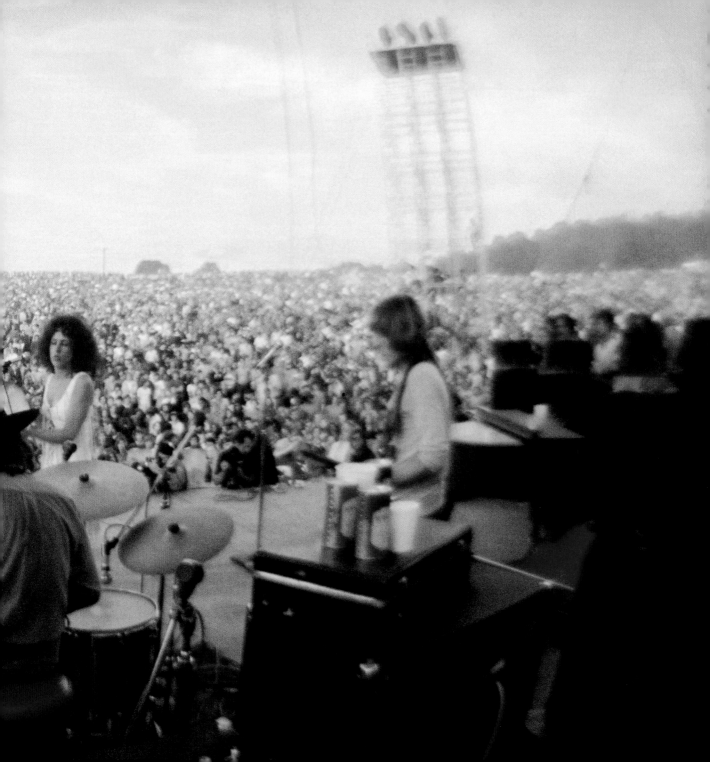

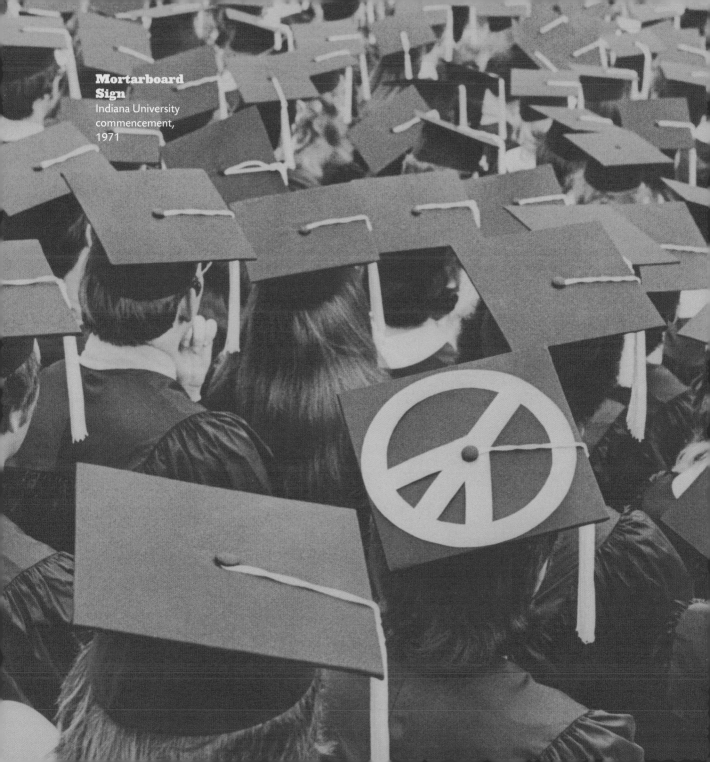

Mortarboard Sign
Indiana University commencement, 1971

chapter

The 1970s

Idealism and Consensus in Decline
CLOSE-UP: Peter Max
New Energy in the Antiwar Movement
CLOSE-UP: John Lennon
Americans Turn Against the War and Against Nixon
The Symbol Finds a Home in New Movements
CLOSE-UP: Bob Dylan
The Campaign Against Nuclear Power

"All we are saying

IN THE SPRING OF 1970, when it looked as if America had seriously begun to reduce its role in the Vietnam War, President Richard Nixon decided to widen it. In so doing, he breathed new life into the antiwar movement and its emblem, the peace symbol. ☮ Nixon approved a joint American and South Vietnamese incursion into Cambodia. He **is give** knew his decision would be unpopular, but he believed a short-term invasion would relieve military pressure on South Vietnam. "Vietnamization," the White House policy of drawing down the number of American troops in the field and replacing them with well-equipped South Vietnamese troops, needed time to work. Nixon was not sure whether indigenous

peace

forces acting on their own could hold off the North Vietnamese Army and Viet Cong guerillas. He hoped the Cambodian invasion, coupled with a new round of bombing raids on North Vietnam, would encourage all sides to meet at the bargaining table and negotiate peace. Expanding the war would end it sooner, he argued. ☮ Nixon revealed the attack on April 30 during a nationally televised address. The next day, as he left a Joint Chiefs of Staff briefing,

National Guardsmen kill four students at Kent State	Greenpeace is founded in Vancouver, B.C.	Equal Rights Amendment sent to states for ratification	Last American troops are withdrawn from Vietnam	President Richard Nixon resigns
70	**71**	**72**	**73**	**74**

he walked into a corridor of the Pentagon and chatted with Defense Department employees. He expressed admiration for "those kids" fighting the war and compared them with the ones who protested at American universities. ☮ "You see these bums, you know, blowing up the campuses," the President said in a conversation widely reported in the press. "Listen, the boys that are on the college campuses today are the luckiest people in the world, going to

a chance."

the greatest universities, and here they are burning up the books." ☮

While the Cambodian invasion moved forward, college students began demonstrations all over the country. Protesters at Kent State University in Kent, Ohio, symbolically buried the Constitution, torched the ROTC building, and broke windows downtown. Ohio's governor called out the National Guard at Kent State to enforce the riot act. On May 4, guardsmen killed four students and wounded

—John Lennon

several others. Some of the victims had merely been in the wrong place at the wrong time, changing classes when the firing started. The shootings particularly angered Middle America because they were unprovoked. ☮

Saigon falls to North Vietnamese

First Apple computer is released

Clean Water Act becomes law

Environmental emergency at Love Canal

Energy crisis cripples U.S

75 **76** **77** **78** **79**

IDEALISM
AND CONSENSUS
IN DECLINE

Vietnam Cartoon
A bull's-eye for peace

Scream of Agony
A teenager kneels over a Kent State victim.

WHILE AMERICA REACTED WITH HORROR to the four killings at Kent State and two more May 14 at Jackson State University in Mississippi, many who formed what Nixon called the "Silent Majority" continued to support the war and cling to conservative values. They had resisted the excesses of the 1960s counterculture. They applauded the President when he framed the growing unrest on the nation's campuses as an either/or proposition: Either college administrators, faculty, and students stood firmly for the laws and rights of the American government or they supported violence as an acceptable route to reforms.

But even Middle America faced new challenges to its old ways of thinking. More Americans began to question their government and the pillars of their society after revelations about the conduct of the Vietnam War, damage to the environment, and dirty political tricks came to dominate the headlines. The decade of the 1970s seemed to spin in new and unexpected directions, flinging interest groups such as feminists, environmentalists, and peace activists further and further from each other, as well as from the Silent Majority. Political, ethnic, and social groups who shared common goals in the 1960s chose their own paths and cut the cords that bound them together. As Boston University history professor Bruce Schulman observed, "Americans chased new pasts, new futures, new Gods—and they chased them by and for themselves." Instead of pursuit of the common good, the 1970s gave Americans the "Me Generation."

Small wonder that idealism suffered in the seventies. An academic organization at

FLASHBACK: 1970

- On the first Earth Day, 20 million Americans turn out to raise public awareness of environmental issues.
- "Doonesbury," the comic strip by Garry Trudeau, makes its debut.
- Breakup of The Beatles is announced.

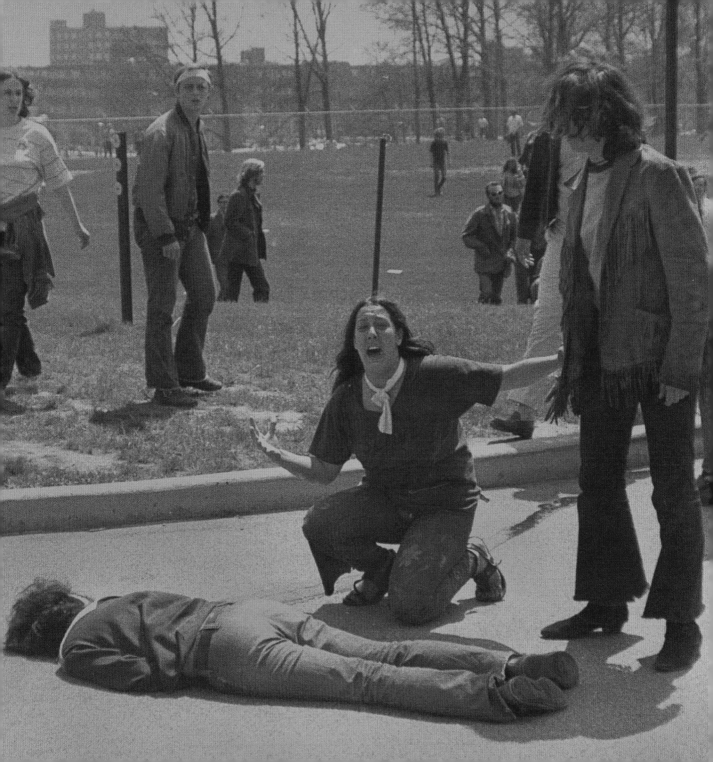

the University of Michigan noted America's changing attitudes in a survey it had been administering for years. One of its standard questions was, "Is the government run by a few big interests looking out for themselves?" The percentage of people answering "yes" more than doubled—from 26 to 53—between the hopeful civil rights year of 1964 and the darker year of 1972. Meanwhile, in the early 1970s, a third of Americans in their late teens and early 20s thought marriage had become obsolete, and half said they considered no fellow citizen worthy of admiration. Nearly half of survey respondents considered America a "sick society," as evidenced by the agonizingly slow end to the war in Southeast Asia and the divisive problems on the home front. And those were the survey results *before* Americans learned of the magnitude of the Watergate scandal that toppled Nixon from the Presidency.

Again and again as new forces pushed America in new directions, activists drafted the peace symbol into their causes. Environmentalists, opponents of nuclear power, and the remnants of the antiwar movement marched under the banner of peace. And not just in the U.S. All over the globe, ordinary people embraced the peace symbol. Peggy Duff, general secretary of the CND, wrote in 1971: "I have found it all over the world, on Glasgow bus shelters, on tiny villages in East Anglia and the Isle of Wight, far afield in the United States, in Greece, in Japan." From antiwar protesters in Europe to apartheid foes in South Africa, whose government tried to ban it in 1973, the peace symbol became a universal touchstone in the 1970s for those who longed for a better world.

True to the centrifugal forces of the decade, opponents of the changes symbolized by Gerald Holtom's simple design twisted its meaning for their own ends. In an attempt to discredit the burgeoning antiwar movement, the John Birch Society published an attack on the peace symbol in its June 1970 issue of *American Opinion*. Magazine writer David E. Gumaer, reported to be an evangelical Christian, called the symbol a manifestation of a witch's foot or crow's foot, both icons of the devil in the Middle Ages. Super-patriots began distributing bumper stickers displaying the peace symbol arrayed like footprints in the sand, next to the words, "Footprints of an American Chicken." Conservative pamphleteers in California called the peace symbol "the Broken Cross of the Antichrist" and tried to link it to "godless Communism." ☮

What's in a Symbol
American Opinion magazine, published by John Birch Society Founder Robert Welch, compared the familiar peace symbol to an anti-Christian "broken cross" carried by the Moors when they invaded Spain in the 8th century. A recent national Republican newsletter noted an ominous similarity to a symbol used by the Nazis in World War II; some experts say it was a letter in an ancient Nordic alphabet. Any resemblance, however, is probably coincidental. The peace design was devised in Britain for the first Ban-the-Bomb Aldermaston march in 1958. The lines inside the circle stand for "nuclear disarmament." They are a stylized combination of the semaphore signal for *N* (flags in an upsidedown *V*) and *D* (flags held vertically, one above the signaler's head and the other at his feet).
Now the peace hieroglyphic is ubiquitous. It has appeared hanging around the necks of G.I.s in Viet Nam; on a fast-selling line of women's dresses; fashioned into belt buckles, cuff links, rings and tie clasps.

NAZI EMBLEM

Time Magazine reports on conservative reactions to the peace symbol.

Kent State Reaction (Opposite) Teachers protest fatal shootings, May 1971.

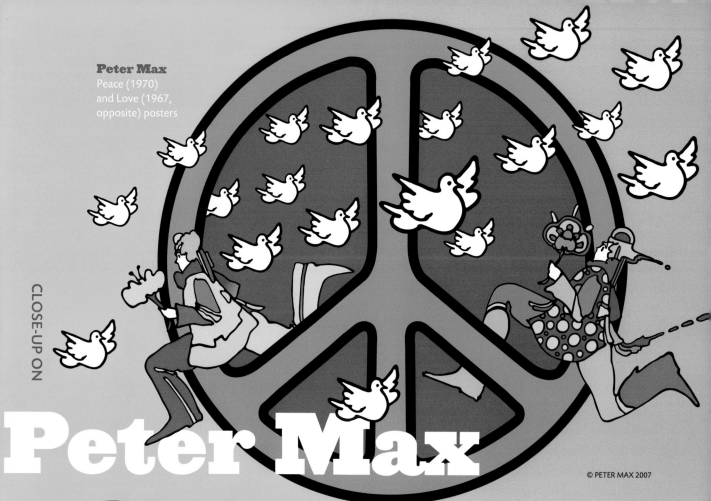

Peter Max
Peace (1970)
and Love (1967,
opposite) posters

Peter Max

P EACE AND HARMONY have long been dominant themes in the art of Peter Max. From the Summer of Love in 1967, when his posters became the visual expression of youthful exuberance, to his images of the spirit of America that helped raise funds for the families of those lost on 9/11, Max has created feel-good art that expresses the times.

Born in Germany in 1937, Max grew up in China, Israel, and Paris before moving to New York City as a teenager. "Captain Marvel" and "Flash Gordon" comic books, Hollywood movies, Eastern spiritualism, love of astronomy, and high-energy music shaped

him. His flowing lines and bold, typically warm colors captured the imagination of the Baby Boom generation—and held it as its members matured.

"My Cosmic period of the late '60s was a visual translation of the euphoria and expansion I experienced during those times," Max has said. "It seemed that art was no longer something I did, but something that happened to me."

Max added to the vocabulary of the 1960s by accident. Asked by a friend to provide promotional materials for a just-for-fun Easter gathering in Central Park in 1967, Max looked around and found the words "Be" and "In" left over from earlier works. He put them together as graphic elements on a new design and added the event's date and place, along with the words "Bring Picnic." The friend recruited kids to distribute hun-dreds of thousands of leaflet-size copies of Max's design around Manhattan—handing them out on streets, tacking them to doors, and placing them in mailboxes. One of the recipients called Max and asked if he planned to attend the "be-in." "The what?" the artist replied. Only then did Max realize he had inadvertently contributed to coining a shorthand name for the gatherings of the hippie era. Hundreds of thousands attended the get-together at the park's Sheep Meadow, just to hang out and "be."

© PETER MAX 2007

Max painted his popular Peace poster in 1970. In primary colors, it features two people prancing and carrying flowers through the peace symbol. A flock of white doves surround the duo as if enveloping them with a blessing.

Max continues to paint and stay active in support of ecology, human and animal rights, the peace movement, and a host of other causes. No doubt, his current work meets with approval from those who embraced his art in an earlier era of peace and love. ☮

This F-8C Vought Crusader, a relic of the Korean War, "landed" in San Francisco's Larsen Park in the early 1960s . . . to the delight of many parents and children. It quickly became a San Francisco landmark, with countless kids climbing on it and pretending to fly. In 1972, on a family outing, I spotted the jet and took this picture of my two-year-old daughter, Dawn, and my wife, Jannice, peeking inside. Graffitists had "decorated" the plane with various pro-war and antiwar sentiments. Unfortunately, it had some unkind religious and political statements painted on it. In the early 1990s, the jet was removed from Larsen Park when it was discovered that it was coated in toxic lead paint. The restored Vought Crusader is now part of the Pacific Coast Air Museum in Santa Rosa, 60 miles north of San Francisco.

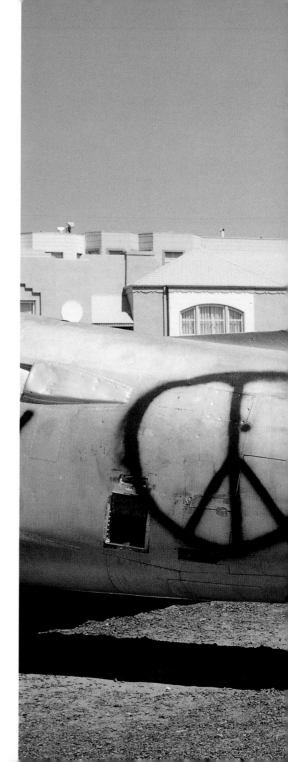

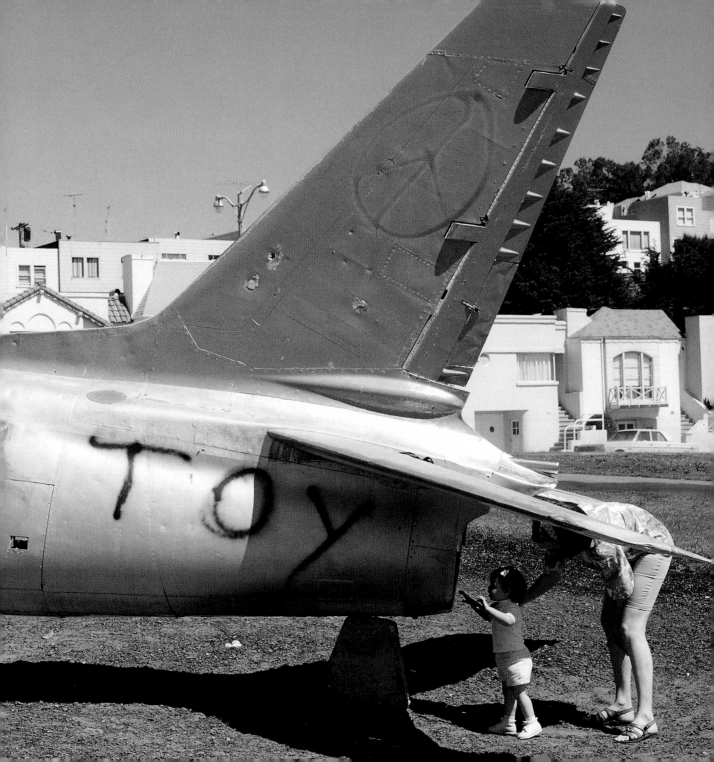

NEW ENERGY IN THE ANTIWAR MOVEMENT

My Lai Massacre
Lt. William Calley leaves court in 1970.

THE SHOOTINGS AT KENT STATE and Jackson State revitalized the antiwar movement, which had begun to lose energy as American soldiers began coming home.

In August 1970, four radicals planted a powerful bomb at the University of Wisconsin. They targeted the Army's Mathematics Research Center, a think tank that supported the military's counterinsurgency programs in South Vietnam. The radicals detonated nearly a ton of ammonium nitrate and jet fuel in a van they parked at a loading dock outside the research center. The blast killed a university researcher and wounded four others. The bombing, while one of the worst episodes of antiwar violence, had negligible impact on the war itself; the vast majority of Americans condemned the use of murder as a tool of political change.

More effective were the protests of Vietnam Veterans Against the War, a group of disaffected soldiers who had returned home after their tours of duty and found fresh energy in the demonstrations of the early 1970s. Hundreds of veterans traveled to Detroit in December 1970 to testify in the so-called Winter Soldier investigations. They spoke publicly about atrocities committed by Americans in South Vietnam. Killings of Vietnamese civilians came to light, underscoring the previous year's revelations about the massacre of as many as 500 men, women, and children at the village of My Lai. Lt. William Calley, who ordered the

FLASHBACK: 1971

- "The Pentagon Papers," secret Department of Defense documents about decision-making in the Vietnam War, are published by the *New York Times*.
- Eighteen-year-olds get the vote with the ratification of the 26th Amendment.

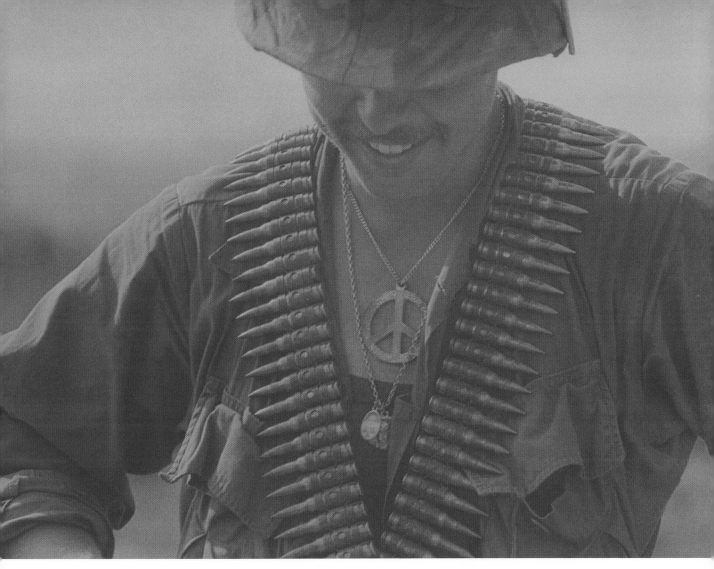

massacre, was found guilty of murder in March 1971 and received a life sentence. The court-martial rejected the argument that Calley had merely followed orders from his superiors; the trial and verdict accelerated the slide of public opinion against the war. Calley was placed under house arrest while his case was appealed. He was released after three and a half years, having served no time in prison.

Conflicted
Soldier in Vietnam wears bandolier, peace symbol.

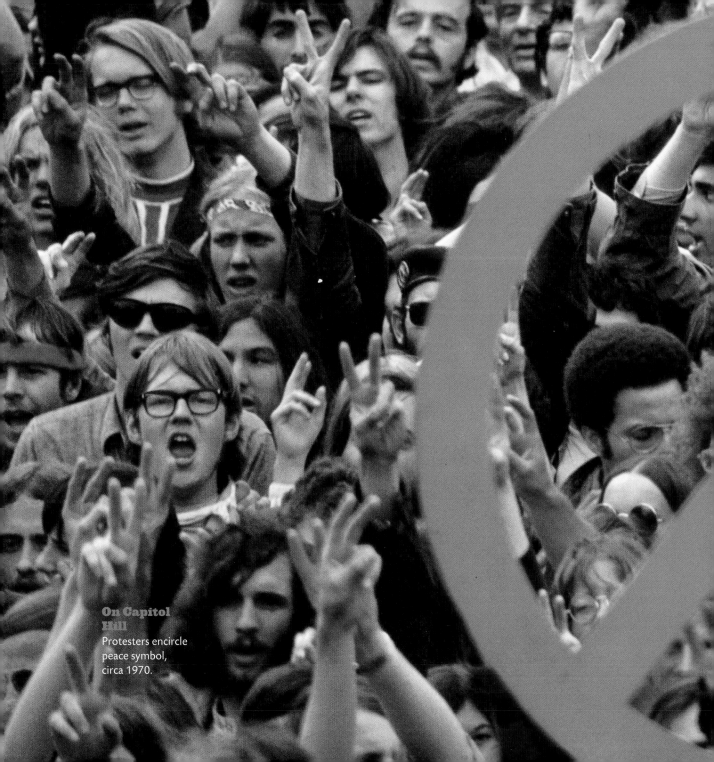

On Capitol Hill
Protesters encircle peace symbol, circa 1970.

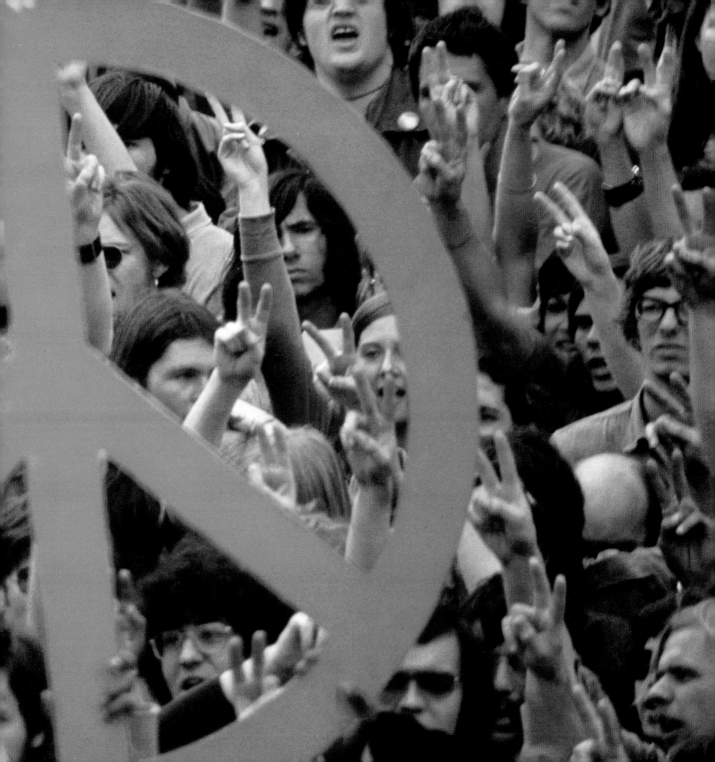

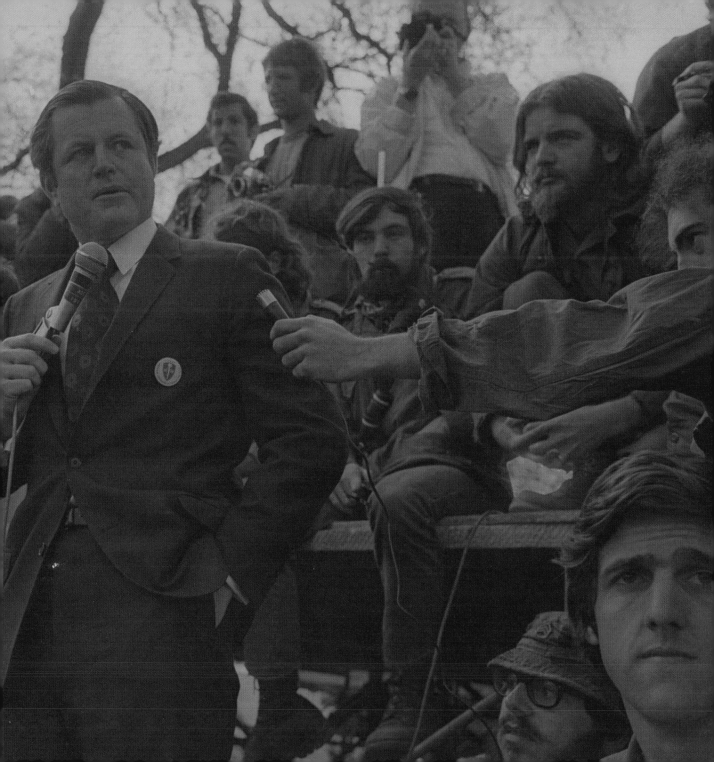

For the first time, large numbers of Hispanic Americans rallied against the war in the early 1970s. Hispanic high school students had staged antiwar walkouts as early as 1968, but the movement didn't blossom until the National Chicano Moratorium Committee organized protests in 1970. As many as 30,000 people—the largest political gathering of Hispanics in America to that time—marched in Los Angeles to urge youths to resist military service in favor of fighting social injustice on the home front. Their anger had been fueled by the high percentage of Hispanics serving in frontline combat units. Marchers carried peace signs and a placard that read "*Ya Basta la Guerra, Gringo*—Enough War, Gringo."

In April 1971, more than a thousand Vietnam Veterans Against the War traveled to Washington, D.C., to take part in an antiwar rally estimated at a quarter-million participants. They had been asked to take their concerns to the nation's capital by John Kerry, a young member from a wealthy Boston family. Kerry, a Yale graduate, had been wounded and decorated in South Vietnam but joined the peace movement on his return to America. In the beginning of a political career that would take him to within a whisker of the Presidency in 2004, Kerry encouraged the veterans group to lobby legislators. "I saw guys [in Detroit] who couldn't talk about what they'd done in Vietnam without crying," he said. "That's when I realized we had to take this thing to the government."

> "**I saw guys who couldn't talk about what they'd done in Vietnam without crying.**"

At the demonstrations, veterans made brief speeches and threw their combat medals over a fence surrounding the Capitol. All along the broad streets between the White House and the Capitol, teachers, bakers, clothing workers, students with long hair, veterans, and lovers holding hands joined in the protest. One section of the march included men in business suits and ties, their hair closely cropped, behind a banner reading "Business Executives for Peace." Many of the marchers carried flags from Southeast Asia, flags hung upside down in the universal sign of distress, and American flags with the stars replaced in the field of blue by a white peace symbol. A member of the Daughters of the American Revolution approached one of the protesting Vietnam veterans. "Son, I don't think what you're doing is good for the troops," she said. "Lady," the veteran replied, "we are the troops."

Referendum
Buttons urge 1970 vote on future of war.

Anitwar
(Opposite) Ted Kennedy meets veterans, including John Kerry, right.

The crowd cheered Kerry on and demanded an immediate end to the war. In a widely reported appearance a short while later at a meeting of the Senate Foreign Relations Committee, Kerry vowed to "search out and destroy the last vestige of this barbaric war, to pacify our own hearts, to conquer the hate and fear that have driven this country these last ten years and more."

Pentagon Papers
Media won right to print "secret" war history.

Peace Flag
(Opposite) Protesters wave banner in Washington, 1971.

Resistance to violence, the draft, and war had been ongoing among pacifists and conscientious objectors for decades. For years prior to the Vietnam War, such activists as A. J. Muste, Barbara Deming, Jim Peck, and David Dellinger had been at the forefront of the peace movement in America, though the movement itself received little attention from the mainstream media. A writer and organizer in the War Resisters League (WRL), Dellinger declared that "the war in Vietnam is a logical expression of America's profit-oriented economy and self-righteous foreign policy, both of which have been with us from the beginning."

Dellinger and other antiwar advocates got an unexpected boon in August 1971 when the *New York Times* began publishing excerpts from a secret, Pentagon-commissioned history of American political and military decisions affecting Southeast Asia. Daniel Ellsberg, a national security consultant who leaked the documents, said he did so to try to get America out of a "wrongful war." The 7,000 pages of documents known as the "Pentagon Papers" demonstrated widespread deception about the conduct of the war, including raids and air strikes that took place in the 1960s while then President Lyndon Johnson assured America he would not expand the conflict. Although the documents did not extend past Johnson's Presidency, President Nixon attempted, unsuccessfully, to prevent their continued publication. The Pentagon Papers increased the so-called credibility gap, leading more and more Americans to distrust what their government told them about the war. ☮

THE SECRET HISTORY OF THE VIETNAM WAR

THE COMPLETE AND UNABRIDGED SERIES AS PUBLISHED BY
The New York Times

THE PENTAGON PAPERS

BASED ON INVESTIGATIVE REPORTING BY NEIL SHEEHAN.
WRITTEN BY NEIL SHEEHAN, HEDRICK SMITH, E. W. KENWORTHY AND FOX BUTTERFIELD
WITH KEY DOCUMENTS AND 64 PAGES OF PHOTOGRAPHS

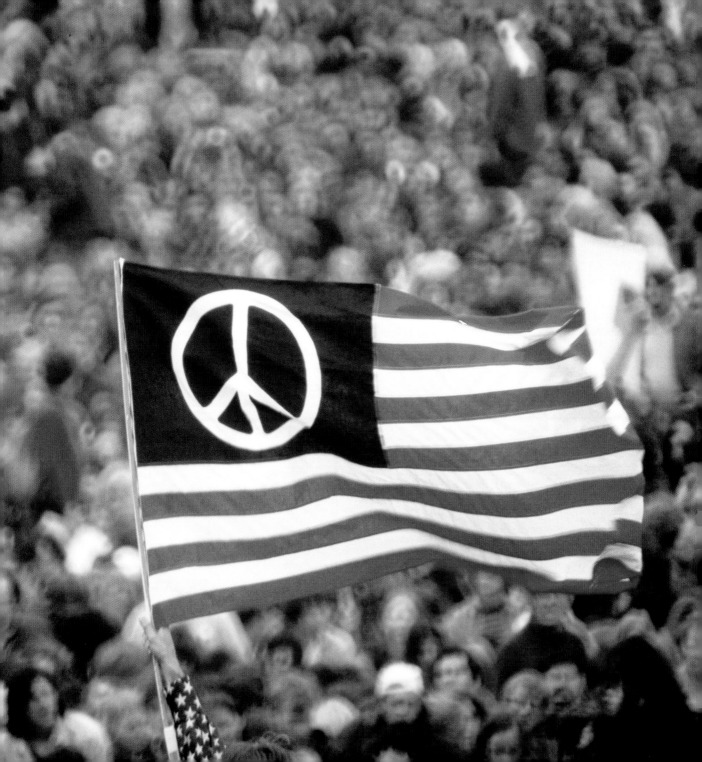

John Lennon

A MOSAIC AT THE STRAWBERRY FIELDS MEMORIAL in New York's Central Park encircles the word "Imagine." Fans who visit to pay respects to former Beatle John Lennon sometimes arrange flowers and strawberries on the stones. They form a circle to enclose the single word, scored by a vertical diameter and two radii drooping downward. The combination invokes a gentle command: Imagine peace.

Lennon did. Yet Brian Epstein, the Beatles' manager, constrained Lennon and his bandmates from speaking out against war and nuclear proliferation in the mid-1960s. Epstein feared controversy would hurt album sales. As the Vietnam War dragged on, however,

and especially after Epstein died in 1967, Lennon began to speak his mind. He did so slowly at first, by wearing a CND badge to show his support for the Campaign for Nuclear Disarmament. Then, after his 1969 marriage to Yoko Ono, Lennon used his star power to promote peace in his own idiosyncratic way. Lennon and Ono invited reporters to interview them while they lay in their honeymoon bed in Amsterdam and other cities. Lennon called it "Studio Bed Peace." As he tried to explain his ideas, he found himself repeating a phrase: "Give it a chance." In a Montreal hotel room, amid bunches of carnations, he wrote and recorded the song "Give Peace a Chance." He felt it resonated with the American civil-rights movement. In his "secret heart," he said, he wanted to write something "that would take over 'We Shall Overcome' " as the anthem of the peace movement.

He turned next to a grand and ultimately disappointing plan to spread peace through the distribution of peace ballots and a worldwide Peace Party. He paid for giant billboards, placed in major world cities and proclaiming, "WAR IS OVER! If you want it. Happy Christmas from John and Yoko." New York City's version overlooked Times Square.

The ex-Beatle's most lasting contribution to peace, however, may have been his 1971 song "Imagine." It asked listeners to envision a world without greed, hunger, or violence: "Imagine all the people, living life in peace." Those words lived on after Lennon's 1980 assassination by Mark Chapman, a deranged fan, at the entrance to the Dakota, Lennon's apartment building across the street from Strawberry Fields. Now, years later at Strawberry Fields, fans still keep Lennon's dream of peace alive. ☮

AMERICANS TURN AGAINST THE WAR AND AGAINST NIXON

BY THE TIME OF THE PENTAGON PAPERS' PUBLICATION, 71 percent of Americans had joined the doves, agreeing in national surveys that it had been a mistake to get militarily involved in South Vietnam. As support declined, so did American participation in the Vietnam War. More and more troops came home as Vietnamization shifted an ever greater burden to the South Vietnamese.

President Nixon enjoyed personal victories in 1972. He opened American diplomatic relations with the People's Republic of China, which had been closed for two decades. Then Nixon outmaneuvered George McGovern, his Democratic opponent in the presidential election, by promising a swift end to the Vietnam War. Nixon pushed his secretary of state, Henry Kissinger, to work out an acceptable peace agreement among the combatants in Southeast Asia. Kissinger delivered the framework for an accord one week before the November 1972 elections, announcing, "Peace is at hand." Nixon easily won reelection. He even seemed to deliver on his promise when, after a short but vicious bombing campaign in December 1972 to encourage North Vietnam to sign off on the peace agreement, he announced the negotiated settlement of the Vietnam War.

American troops came home in 1973. However, the fighting continued. The American pullout shifted the burden of fighting entirely to the South Vietnamese Army, which lacked leadership and desire equal to the task. Saigon fell in 1975, leaving Americans

Nixon and Vietnam
1969 cartoon suggests Nixon's burden of war.

FLASHBACK: 1973

■ The Amercan Indian Movement, led by Russell Means and Dennis Banks, holds out for 71 days against U.S. marshals to protest Indians' living conditions.

■ Billie Jean King beats Bobby Riggs in a "Battle of the Sexes" tennis match.

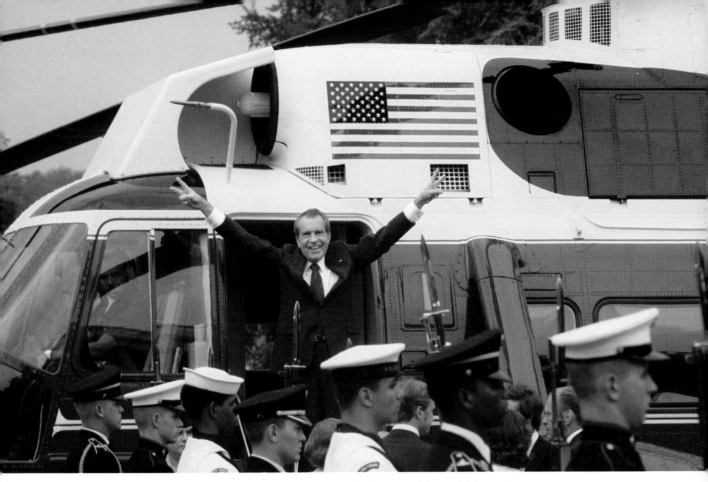

haunted by ignominious images of full-to-overflowing helicopters lifting off from the crowded roof of the U.S. embassy in Saigon.

By that time, Nixon was gone. Americans learned that the orders to burglarize the Democratic Party's national headquarters at the Watergate complex in Washington, as well as a host of other dirty political tricks in the summer of 1972, had come from the White House. After two years of dodges, delays, denials, and desperate cover-ups, and with impeachment threatening, Nixon held up both hands, flashed his signature "V" signs with his fingers—for peace, or perhaps some Pyrrhic victory—and stepped aboard the Marine One helicopter, the first American to resign the office of the Presidency. ☮

Nixon Resigns
Ex-Pesident flashes peace signs on way out.

WAKE UP
THERE'S CRIME IN
NIXON SOLD US OUT
TO THE MILITARY -
INDUSTRIAL COMPLEX

CALIFORNIA
053 AQR

CALLEY 22
NIXON 1 365 745

LACC

MERICA!
WHITE HOUSE

NO AMNESTY FOR
NIXON-THE CORRUPT
WAR CRIMINAL

Rolling Billboard
Car trunk, 1973, displays anti-Nixon tirade.

Peace Candles By the 1970s, when this picture was taken, the peace symbol had been expressed in all kinds of media, from candles like this one to human bodies to grenade pins. Of course, the peace symbol went hand-in-glove with the peace sign—those two ubiquitous fingers, index and middle, raised in hope. It's ironic that just as antiwar demonstrators were flashing the sign to one another and the world as a salute of peace, their nemesis, President Richard Nixon, was using the same gesture to express success, stalwartness, sometimes victory. The victory part he copied from Winston Churchill. The British prime minister famously led his people through their finest hour, against the Germans in World War II, rallying them with his V-for-victory gesture, palm facing outward. To the English, doing it the other way around—palm inward—is a crude expression, far from any solicitation of victory, or peace.

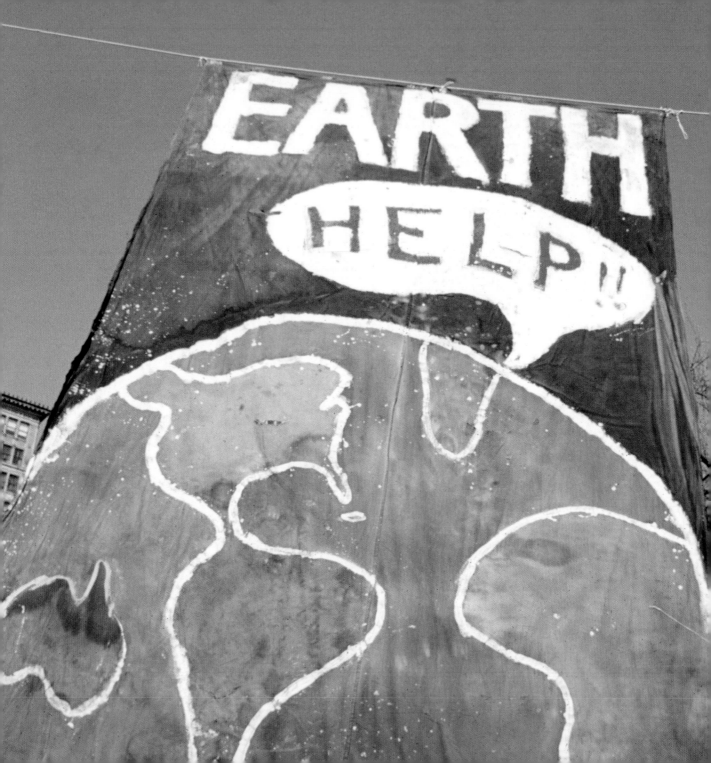

THE PEACE SYMBOL FINDS A HOME
in NEW MOVEMENTS

ACTIVISTS FOUND NEW CAUSES in the environment, nuclear power, women's rights, and the rights of ethnic groups and homosexuals. A proposed Equal Rights Amendment went down to defeat at the hands of state legislatures, while women, minorities, and gay Americans continued to fight social inequities.

In 1970, America celebrated Earth Day for the first time. The nation-wide observation, on April 22, emerged from efforts to bridge the gap between legislative support for environmental protection and grassroots activism. Gaylord Nelson, a U.S. senator from Wisconsin, proposed a national teach-in to focus attention on the environment. He envisioned a small obser-vation, but the movement took on a life of its own in scores of American cities. Thousands packed a block-long bubble in New York City to breathe filtered air; within an hour, the oxygen had taken on the tang of marijuana smoke. Boston demonstrators targeted the noise made by jets; marchers in New Jersey dumped a coffin bearing the names of America's polluted waterways into the Hudson River.

The environmental movement spread to include activists who managed to win cre-ation of the Environmental Protection Agency, as well as passage of the Clean Air Act in 1970. As a result of their actions, the armed forces gave up using mutagenic defoliants in Southeast Asia, and plans for American development of supersonic jets were scrapped. Over the years, Earth Day advocates incorporated the peace symbol into their observances, and featured it on "Earth Day" T-shirts.

The ecological group Greenpeace forged connections between the grassroots move-ments of the 1960s, activism for peace, and environmental protection. "We have pro-gressed from a social or cultural recognition of each other to an ecological one," one of Greenpeace's founders said. "We are now dealing with the entire earth as well as our immediate neighbors."

ECOLOGY NOW!

Ecology
Symbol gains green stripes for environmental focus.

Help!!
(Opposite) Banner from first Earth Day, 1970

Greenpeace
Badge merges ecology and peace.

In the Line of Fire
(Opposite) Greenpeace boat takes on whalers in 1970s.

The group began as the Don't Make a Wave Committee in Vancouver, Canada, in 1970. The committee targeted American nuclear testing at Amchitka Island in western Alaska. One nuclear blast had occurred in 1965 and a second in 1969. The protests aimed to prevent a third that was scheduled for the autumn of 1971. Meeting in February 1971 in the Fireside Room of the Vancouver Unitarian Church, the group discussed possible strategies to confront the bomb and settled on sailing a boat toward Amchitka to draw attention to the blast. As the meeting broke up and everyone drifted into the church courtyard, a Quaker flashed the "V" sign with his fingers and said, "Peace." Ecology activist Bill Darnell replied, "Make it a green peace," unknowingly supplying the group with its name. The group raised money for its trip by selling two-dollar green-and-yellow buttons that combined the peace and ecology symbols—the latter a combination of the letters "e" for the Earth and "o" for the organisms that call it home.

On September 12, committee members set sail for Amchitka in an 80-foot halibut boat they had renamed *Greenpeace*. Pacific storms prevented them from traveling farther west than Akutan Island, 600 miles short of their goal. Crew members climbed to the top of a 1,600-foot-tall hill and built a cairn of rubble while a 70-mph wind howled over the island. They made a peace symbol by rearranging volcanic rocks on the ground.

The U.S. Coast Guard arrested the crew a short time later on a tariff technicality, but not before some aboard the Coast Guard ship had slipped the Greenpeace protesters a note saying, "We are behind you one hundred per cent."

FLASHBACK: 1975

- Bill Gates and Paul Allen start Microsoft.
- In "The Thrilla in Manilla," Muhammad Ali beats Joe Frazier.
- South Vietnam falls to North Vietnam.

Greenpeace was unable to stop the third and final blast at Amchitka. However, the group found a new target for protests in the French-administered islands of the South Pacific. Attempting to prevent a nuclear detonation at a French atoll, another Greenpeace boat was rammed by a French warship but not seriously damaged. Further protests in the mid-1970s interfered with Soviet whaling fleets.

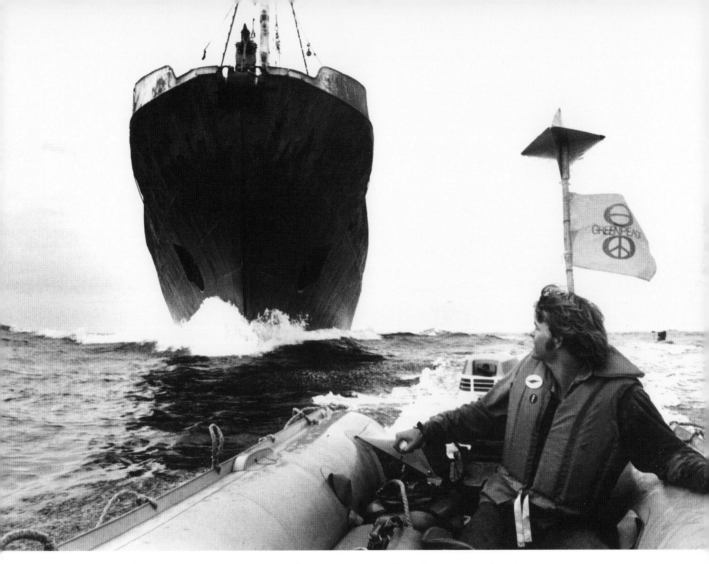

Activists in inflatable boats sailed into action flying Greenpeace flags that combined ecology and peace symbols. Unfortunately, a tragedy brought Greenpeace its biggest headlines. French secret agents sank the flagship of the organization's flotilla in 1985, killing a photographer aboard. The ship had sailed to the South Pacific in an attempt to interfere with another French nuclear test. ☮

Bob Dylan

P ROBABLY NO MUSICIAN has been embraced by so many movements, from
peace to civil rights, as Bob Dylan. Yet in response to fans who adopt his songs
as protest anthems, the enigmatic folk and rock star has remained aloof since
the early 1960s.

Robert Allen Zimmerman grew up in Minnesota but moved to Greenwich Village
and began performing in coffeehouses in 1960. Debuting his seminal "Blowin' in the
Wind" in April 1962 at Gerdes Folk City, Bob Dylan, as he called himself, announced,
"This here ain't no protest song or anything like that, 'cause I don't write no protest

songs." Despite his declaration to the contrary, the song became one of the rallying anthems of the civil rights and antiwar movements.

Dylan tried his hand at political activism briefly in 1963. He flew to Mississippi to sing in support of the Student Non-Violent Coordinating Committee, which was trying to register black voters. Dylan and his then romantic partner Joan Baez also sang at the march on Washington in August 1963, where Martin Luther King, Jr., gave his "I Have a Dream" speech.

After that year, Dylan stepped back from political organizations just as the new counterculture and the peace symbol spread into every corner of America.

The national media proclaimed Dylan the spokesman for his generation because of songs like "The Times They Are A-Changin'," "With God on Our Side," and "A Hard Rain's A-Gonna Fall." He fought against attempts to turn him into a public figure, demanding that he have the privacy to write and perform without being summoned to give his opinions on every issue of the day.

His friend, the late George Harrison of the Beatles, told reporters in 1969, "He [Dylan] didn't make himself into a cult—the Press did. . . . Now he can't understand why people want to ask him . . . what to do about Vietnam. He just wants to write and sing songs." Harrison did manage to persuade Dylan to perform at a concert for relief of war victims in Bangladesh, the former East Pakistan, in 1971. Dylan also participated in the Live Aid concert for African hunger relief in 1985. ☮

THE CAMPAIGN
AGAINST NUCLEAR POWER

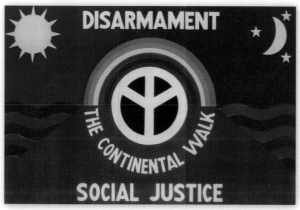

THE USE OF THE PEACE SYMBOL came full circle in the middle and late 1970s as activists enlisted it in campaigns to end the construction of nuclear power plants and to disarm the world's nuclear superpowers. A small group of protesters in the War Resisters League walked from Ukiah, California, to Washington, D.C., in 1976. The Continental Walk attracted supporters from the Quaker American Friends Service Committee and the Women's International League for Peace and Freedom. Thousands of people joined the march along the way or walked in "feeder tours" through 34 states. They spread a message of nuclear disarmament, resisting a war-based economy, and spirituality—underscored by the presence of Japanese Buddhists among them. The poster publicizing their walk depicted a sun, moon, and rainbow over an inverted peace symbol that some took to mean unilateral disarmament.

A delegation of the marchers went to the White House in hopes of meeting with President Gerald Ford, but he refused the offer. The next day, Ford denounced those who urged cutting the military budget, even though America had been at peace for more than three years.

No Nukes
Continental Walk poster inverts peace symbol.

Seabrook Foes
(Opposite) Marchers head for nuclear plant gate, 1977.

A seminal moment in the "No Nukes" movement occurred in 1974, when organic farmer Sam Lovejoy toppled a 500-foot weather tower erected by Northeast Utilities in Montague, Massachusetts. The utility had hoped to use the tower to gather information for a nuclear reactor it planned to build. Nuclear power plants had always drawn suspicion from skeptics who doubted their safety and feared the long-lasting effects of radioactive waste. Lovejoy fought the criminal charges against him with expert testimony about the dangers of nuclear power and the rights of civil disobedience. He was acquitted on a technicality.

Two years later, Lovejoy and other New England residents formed the Clamshell Alliance to oppose construction of a nuclear reactor at Seabrook, New Hampshire. They

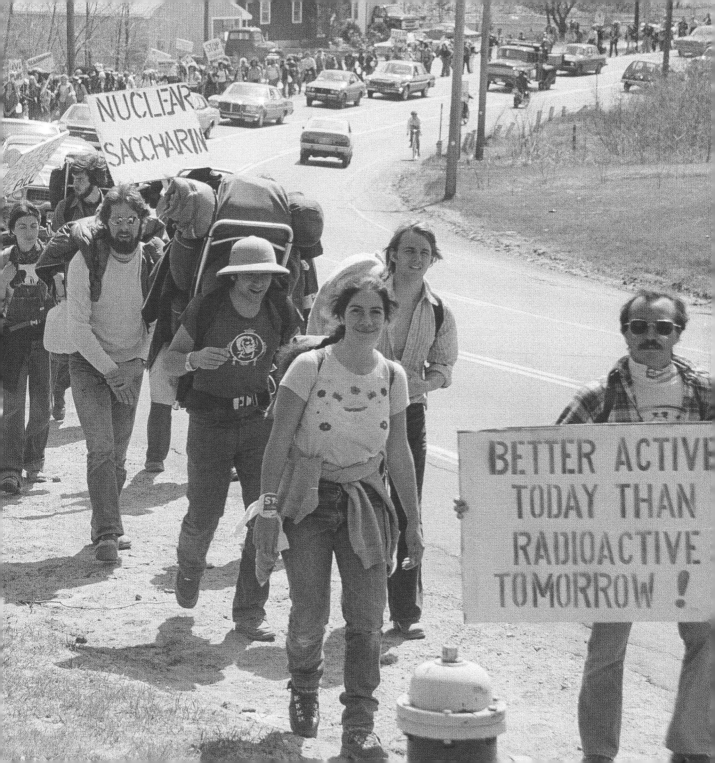

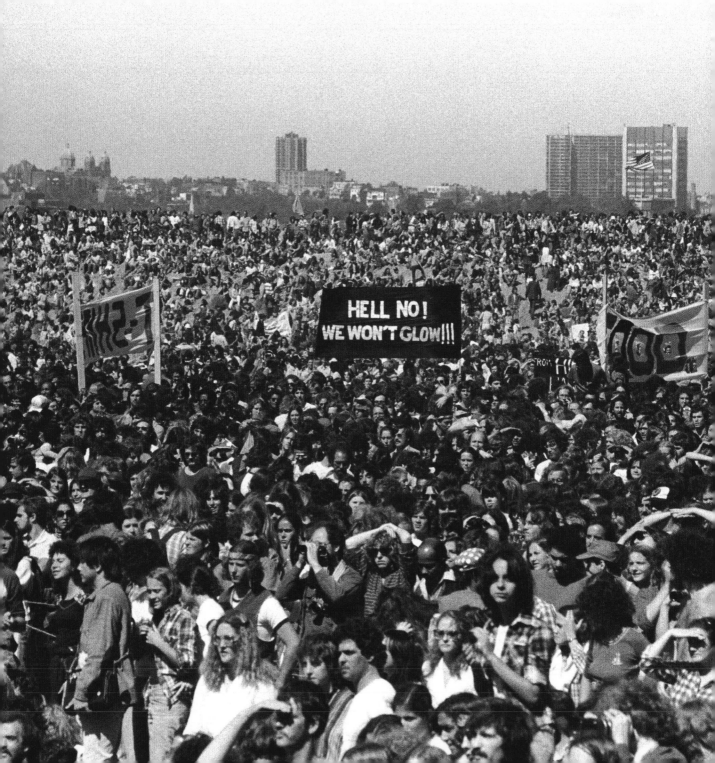

performed acts of civil disobedience, including occupation of the Seabrook site, that led to mass arrests. A long series of protests attracted speakers such as Dr. Benjamin Spock and musicians including Pete Seeger, Jackson Browne, and Arlo Guthrie.

National news media attention to the protests in 1976 and 1977 helped spread the No Nukes movement throughout the nation. The War Resisters League walk that featured the inverted peace symbol had stopped at California's Diablo Canyon nuclear power plant site on its way to Washington, linking the fight against nuclear weapons to opposition to civilian atomic energy. Eight walkers were arrested for blocking the gate. Later, antinuclear protesters who had met during the 1976 march on Washington organized a series of teach-ins and demonstrations. The activists got a boost in 1979 when a near disaster at the Three Mile Island plant in Pennsylvania dramatized the risks of radioactive fuel sources. Ironically, a just released movie, *China Syndrome,* had brought home the perils of nuclear power.

> **"The government was supporting an energy source that could prove as lethal as any war."**

Some 200,000 protesters gathered in New York City in September 1979 in America's largest rally against nuclear power. Many activists who had protested against the Vietnam War joined the antinuclear movement, claiming it was the "Vietnam War brought home."

"By aiding the nuclear industry while assuring the public it had nothing to fear, the government was supporting an energy source that could prove as lethal as any war," a Clamshell Alliance organizer wrote.

Although some plants under construction in the late 1970s eventually began operations, the No Nukes protesters effectively curtailed the proliferation of atomic energy reactors in the U.S. No new commercial nuclear reactor has gone on line since 1996. Only one of Seabrook's two units was completed and produced power.

Protesters working under the umbrella of the peace symbol had helped stop the growth of commercial nuclear power plants. Yet to come in the 1980s was an even bigger challenge: to push for the elimination of tens of thousands of nuclear weapons. ☮

Inverted Peace Sign
It also means unilateral nuclear disarmament.

New York City
(Opposite) Protesters rally after "No Nukes" concert series, 1979.

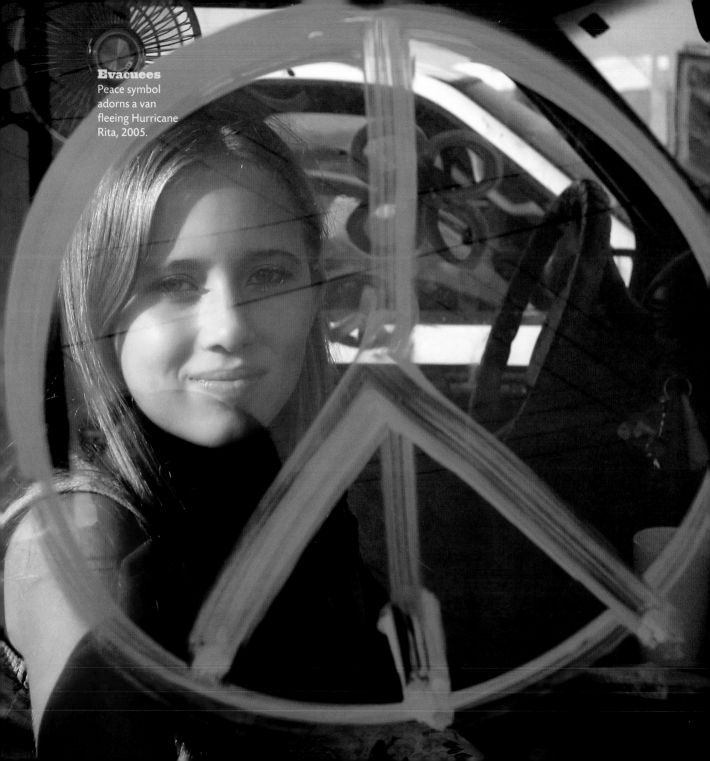

Evacuees
Peace symbol adorns a van fleeing Hurricane Rita, 2005.

The 1980s Through TODAY

On Reagan's Watch
Keeping the Faith
Brand-New Wars
The Peace Symbol Rises Again
CLOSE-UP: Commercialization

Hope is the pillar

George Kistiakowsky, a science adviser to President Eisenhower in the 1950s, became convinced by the end of the 1970s that it was only a matter of time before nuclear war destroyed the world. ☮ Fighting cancer in 1979, he agreed to brief presidential candidates on the nuclear arms race. **that holds up** At the home of Dr. Helen Caldicott, a prominent advocate of nuclear disarmament, he met Democratic candidate Jerry Brown of California and described the new kinds of American weapons that could evade Soviet defenses and deliver nuclear warheads at multiple targets. As Kistiakowsky left the meeting, an alarmed Caldicott pulled him aside and asked, "George, do you think we will survive?" He dropped his gaze and **the world.** replied, "I'll survive my natural life span; you won't." ☮ Nuclear war between the superpowers appeared to be a real possibility at the end of the 1970s. News reporters leaked the fact that President Jimmy Carter had signed two significant presidential directives on nuclear exchanges in August 1979. The first directed the Defense Department to determine what steps the government could take to survive a nuclear attack on American soil. The second called for

John Lennon is assassinated

First woman appointed to Supreme Court

Ronald Regan announces Star Wars defense plan

Vietnam War memorial opens in Washington, D.C.

Berliners tear down Berlin Wall

80 **81** **83** **84** **89**

rethinking the Cold War standoff between the U.S. and the Soviet Union. No longer would the two nations rely on **Hope is the dream** former defense secretary Robert McNamara's decades-old doctrine of MAD—mutually assured destruction—to avoid nuclear war. Instead, Presidential Directive 59 revealed an outline for a "flexible response" to Soviet aggression, including the possibility of fighting a **of a waking man.** limited nuclear war. ☮ Meanwhile, the North Atlantic Treaty Organization decided in 1979 to place ground-based, nuclear-tipped "cruise" missiles in England, Belgium, the Netherlands, West Germany, and Italy. NATO scheduled the deployment for December 1983, giving its Western European allies four years' warning. ☮ Cruise missiles posed new dangers of turning the Cold War hot. They flew just above the ground, rendering them invisible to radar. They were small enough to be moved around the countryside in **—Pliny the Elder** trucks, making their presence virtually impossible to verify. And they could hit their targets in Eastern Europe or the Soviet Union within a few minutes, narrowing the window of time in which World War III could be launched—or avoided. ☮

First U.S. invasion of Iraq

Comprehensive Nuclear Test Ban Treaty opens for signatures

Terrorists attack World Trade Center and Pentagon

U.S. invades Iraq for a second time

50th anniversary of peace symbol

91 **96** **01** **03** **08**

ON REAGAN'S
WATCH

IN AMERICA, NUCLEAR ANXIETY ROSE with the election of Ronald Reagan to the Presidency in November 1980. Coming into office on pledges to expand the military budget and take a hard-line stance in negotiating with the Russians, Reagan and his aides talked of winning a limited nuclear exchange. Thomas K. Jones, a Reagan appointee to a Defense Department post overseeing nuclear weapons, told a reporter for the *Los Angeles Times* that he believed America could bounce back from a nuclear war in two to four years. In fact, he said, everyone could survive an all-out nuclear attack if they could dig enough holes. "The dirt is the thing that protects you from blasts and radiation," Jones said. "If there are enough shovels to go around, everybody's going to make it. It's the dirt that does it."

Faced with finally thinking about the unthinkable, millions of people around the world in the early 1980s rose up in history's largest grassroots peace movement. The sheer numbers, coupled with the short time it took for the nuclear disarmament movement to seize the public imagination, astonished the experts who tracked public opinion. During the fall of 1981 eight major European cities saw mass demonstrations, each attracting between 200,000 and 500,000 protesters. Avoiding nuclear war became a crucial issue almost overnight. It made the peace symbol hip again.

The symbol returned to its 1958 antinuclear origins as 1980s antinuke demonstrators wore it, carried it, painted it as graffiti, and formed versions of it out of their own bodies on beaches and grassy fields. They made the fight

PEACE, BROTHER.

B-1 Bomber
Cartoon suggests Reagan's path to world peace.

> "If there are enough shovels to go around, everybody's going to make it."

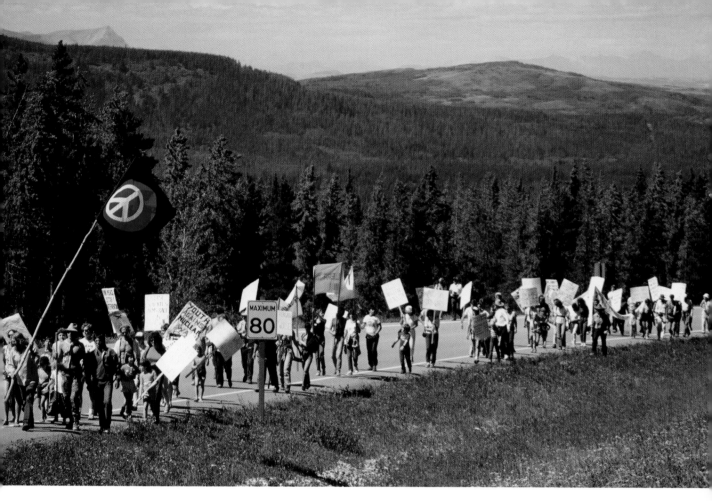

against nuclear weapons, as well as the nuclear power plants that supplied their enriched radioactive weapons materials, the most significant social movement since the 1960s. They did so through expanding the scope of their protests to cities around the world, through linking up with the environmental and feminist movements to broaden their appeal, and, finally, through the concrete results they could claim.

George Kistiakowsky died in 1982. Millions of nuclear protesters who survived him were gladdened that by the late 1980s the superpowers had agreed to remove intermediate-range nuclear missiles from Europe, trim their nuclear arsenals in half, and continue to build on such accords as the Soviet-American Strategic Arms Limitations Talks (SALT) of

Walk For World Peace March
Walkers at Peace Park, U.S.-Canadian border, 1985

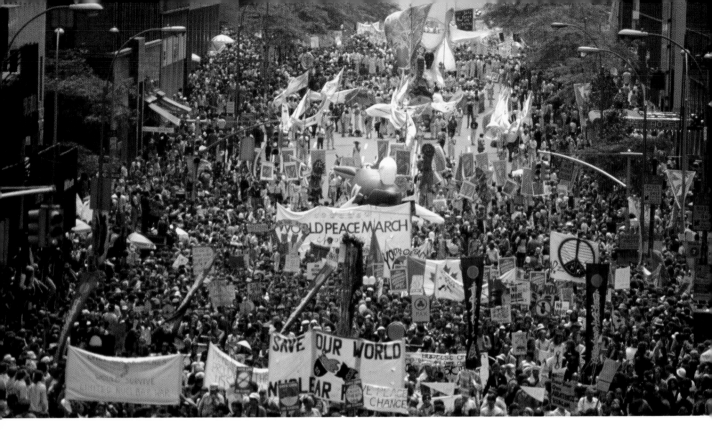

1972 and 1979. Many, like Caldicott, remain hopeful that one day the danger of annihilation will be erased as the last nuclear weapons are destroyed.

Credit for the easing of nuclear tensions belongs to no single person. However, the concept of a nuclear freeze, a sudden halt in the production of nuclear weapons, captured the public imagination after Randall Forsberg proposed it in December 1979. Forsberg, a former Alabama schoolteacher, had learned about nuclear weapons while working at a Swedish peace institute. Her Nuclear Weapons Freeze Campaign urged a mutual halt by the Soviets and Americans to the testing, production, and deployment of nuclear arms. Critics said the idea was too simple for something so complex as nuclear weapons policy.

But promoters found its simplicity to be its strength. Ordinary Americans of all political persuasions could understand a nuclear freeze and support it. After all, the activists said, how many nuclear weapons did America need? If 200 served as a credible deterrent, as

World Peace
Massive march in New York City seeks nuclear freeze.

McNamara had concluded in the 1960s, why did each superpower need tens of thousands? Americans felt a growing sense of unease in the fall of 1979 and spring of 1980, when the Soviet Union invaded Afghanistan. The Senate, worried by this new sign of Soviet aggression, voted against ratifying the White House's SALT II treaty, which negotiated cuts in Soviet and American nuclear arsenals.

A national conference of peace groups met in Washington, D.C., in March 1981 and decided to rally behind Forsberg's idea of a nuclear freeze. Through grassroots campaigns, they began to win support from city councils and state legislatures. The Union of Concerned Scientists, a Boston-based group with tens of thousands of members, supported the freeze with a teach-in day in November 1981. Although the sponsors expected only two dozen schools to participate, 150 eventually joined. By the spring of 1982, three-quarters of Americans supported a nuclear freeze.

The showpiece of the movement's popularity, however, came on June 12, 1982, when nearly a million protesters gathered in New York City as the United Nations opened a special session on nuclear disarmament. Church, labor, theater, and community groups joined in as the demonstrators marched from the UN to Central Park. The demonstrators couldn't easily be dismissed as bearded radicals. They included large numbers of middle-class, middle-aged men and women, including doctors, lawyers, nurses, scientists, and clerics, as well as survivors of the 1945 atomic bombings of Hiroshima and Nagasaki by the U.S. They carried signs with peace symbols and slogans such as "Freeze or Die" and "All We Are Saying Is Give Peace a Chance." They shouted in unison, "Freeze now!" ☮

Salt II
Presidents Carter, Brezhnev kiss after signing.

September 2007 Alive and well, the peace symbol is still showing up in unlikely places, including the conflict-ridden West Bank. These tear gas canisters were formed into the symbol in the village of Bil'in, after a big Palestinian legal victory. Israel's High Court had just ruled that the controversial 425-mile-long West Bank barrier, or wall, being constructed by the government would have to be rerouted in this area. The three-judge panel was "not convinced that it is necessary for security-military reasons to retain the current route," which would have separated the villagers from their farmlands and orchards. In other parts of Israel, the wall has played havoc with Palestinian lives, making it a grueling process for them to get to fields, jobs, and shops to buy necessities. The Bil'in victory was sweet, the celebration hardy, and the peace symbol no doubt heartfelt. But peace itself in this tumultuous land still seems a long way off.

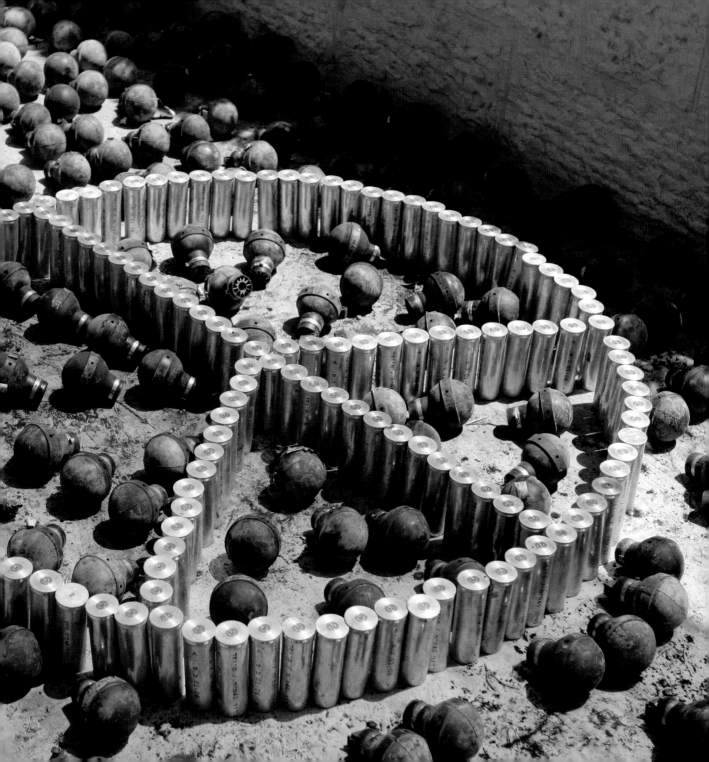

KEEPING
THE FAITH

Philippine Protest
(Opposite) Filipinos urge troop pullout from Iraq, 2004.

IRN Treaty Signing
(Following pages) Presidents Gorbachev, Reagan sign ban, 1987.

WOMEN IN PARTICULAR supported a nuclear freeze. Some were inspired by feminist critiques of male-dominated power structures, while others, like pediatrician Helen Caldicott, were primarily motivated by concern for children whose lives might be cut short by war. Eleanor Smeal, president of the National Organization for Women, said, "When it comes to the military and questions of nuclear disarmament, the gender gap becomes the gender gulf." Groups of women set up peace camps at sites where intermediate-range missiles were to be assembled or deployed. They danced atop a missile silo at Greenham Common in England and blocked the gates of a nuclear missile shipment center in Seneca Falls, New York, site of the first women's rights convention in 1848. Seattle women raised money in the early 1980s to support the freeze through marathon dances, using the slogan "Give Peace a Dance," and so-called peace footraces, promoted as "Legs Against Arms."

In San Francisco, the antinuclear movement set sail in 1983 with the creation of the Peace Navy, backed by the nuclear freeze campaign as well as Quakers, Greenpeace, and other peace organizations. A ragtag fleet of 75 powerboats, sailboats, rowboats, dinghies, canoes, and windsurfers maneuvered around the harbor to call attention to warships carrying nuclear weapons and to protest the arms race. Displaying peace symbols on sails and "Nuke-Free Bay" banners, the fleet released brightly colored helium balloons painted with disarmament slogans in five languages. For its emblem, the flotilla morphed the peace symbol into a boatlike design.

In the early 1980s, nuclear freeze groups, feminism, and the environmental movement, which particularly targeted radioactive waste and fallout, often found themselves in political alignment. Together, they called for a reorientation of power—away from top-down militarism and toward political structures that worked

> **"When it comes to... questions of nuclear disarmament, the gender gap becomes the gender gulf."**

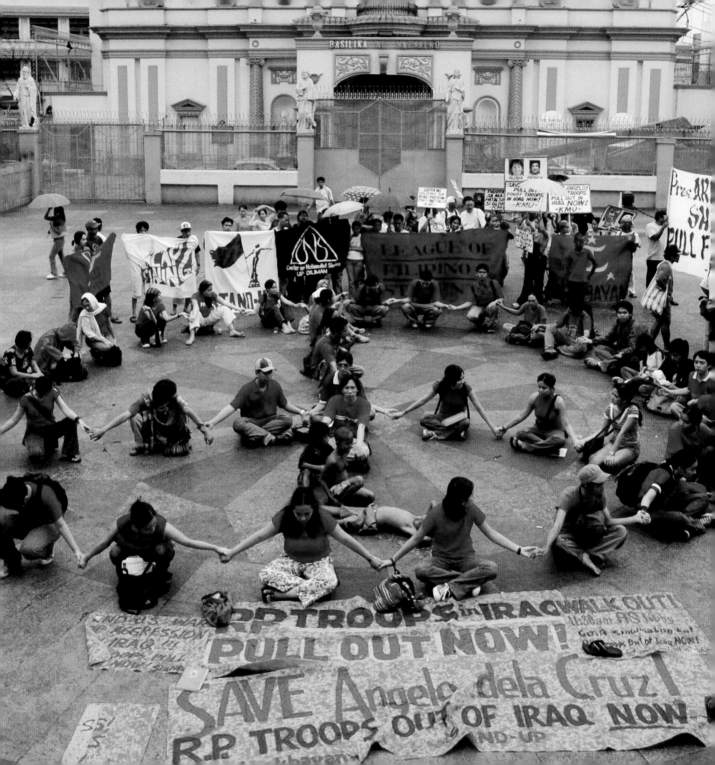

in harmony with the Earth. Green parties captured significant fractions of the electorate in a number of European nations.

Meanwhile, President Reagan set a different agenda. He pledged in 1983 to develop a shield against nuclear attack. He called it the Strategic Defense Initiative, although it quickly became known as Star Wars. Many scientists scoffed at the plan as virtually impossible to implement and a waste of money. Reagan moved forward anyway. He dismissed the nuclear disarmament movement as misguided and told Dr. Caldicott that the massive 1982 rally in New York City had been orchestrated by communist infiltrators.

Star Wars
Artist's 1980s rendering of missile being intercepted

Despite his opposition to the freeze movement, Reagan remained personally popular and won reelection in 1984. Peace advocates, fearing an increased likelihood that their doomsday visions might come true, grew even more active. Arrests for antinuclear civil disobedience peaked at 5,400 in 1987, the year that the National Committee for a Sane Nuclear Policy (SANE) and Nuclear Freeze merged. In one month alone—March 1988—2,100 protesters were arrested at the Nevada Test Site. Meanwhile, membership in antinuclear groups mushroomed. In the 20 months after Reagan began his second term, the rosters of SANE, one of the oldest antinuclear organizations, rose to 150,000 members— nearly four times as many as in 1983. Greenpeace boasted 650,000 members by 1987. Even mainstream church groups, including the National Council of Roman Catholic Bishops, spoke out against nuclear weapons.

To the surprise of many worried observers, Reagan and Soviet President Mikhail Gorbachev concluded a series of agreements to ease nuclear tensions and reduce the size of their nations' nuclear arsenals. One of the most significant was the Intermediate-Range Nuclear Forces Treaty of 1987, which eliminated nuclear-tipped cruise missiles with a range of 300 to 3,400 miles. In a stroke of the pen, the two leaders removed the threat of swift, push-button Armageddon in Europe. Another breakthrough came with the Strategic Arms Reduction Treaty, or START. Treaty negotiations, which had begun in 1982, finally concluded in 1991 with the United States and the Soviet Union agreeing to reduce their nuclear warheads dramatically. The two nations signed the treaty five months before the Soviet Union disintegrated, ending the Cold War. Still, the 2006 *Bulletin of Atomic Scientists* counted 27,000 intact nuclear warheads in the world, the vast majority of them in the U.S. and Russia. Other nuclear nations include France, the United Kingdom, China, India, North Korea, and Pakistan; Israel is frequently rumored to have nuclear weapons. Atmospheric and underground tests of these weapons have been banned since 1992. The ecological and health hazards of the some 2,000 nuclear detonations that have occurred since 1945 are still being evaluated. ☮

FLASHBACK: 1983

■ The Strategic Defense Initiative (SDI), popularly known as Star Wars, is proposed by President Reagan.

■ Lech Walesa, Polish labor organizer, is awarded the Nobel Peace Prize.

BRAND-
NEW WARS

WHILE THE END OF THE 20TH CENTURY witnessed the threat of nuclear war between the superpowers fading, conventional wars flared up among sites of ancient sectarian conflicts: the Middle East, the Balkans, and multitribal African nations. New fears arose that "rogue" nations might find ways to develop and deploy smaller nuclear devises. At the same time, peace activists found new places to deploy the peace symbol.

> **"The peace movement finds itself with a message of peace in a situation where people's emotions have been aroused... in a way they have never been before."**

Antiwar slogans and peace signs and symbols popular in the 1960s received new life when the U.S. led a coalition of nations that ousted the Iraqi Army from Kuwait in the 1991 Persian Gulf war. The fighting in the Middle East lasted only six weeks, allowing little time for antiwar forces to coalesce. Also, the public mood had changed since the 1960s for a variety of reasons. First, many Americans considered the war to be justified, as Iraq had invaded and occupied Kuwait. Second, they supported the massive arms buildup and such a clear-cut conflict, glad to have moved on from the lingering malaise and guilt about the Vietnam War. And third, the armed forces fought the war with volunteers, as conscription had never been reactivated. "The antiwar side had much sensible protest to be proud of," 1960s student protest leader Todd Gitlin wrote about the Persian Gulf war, "along with much effort extended to paint itself into a corner."

Antiwar demonstrators similarly had a hard sell after the terrorist attacks of September 11, 2001. The U.S. launched attacks on Islamic fundamentalists in Afghanistan in October 2001, and invaded Iraq in the spring of 2003 on the assumption that Saddam Hussein's regime had encouraged terrorism and had stockpiled weapons of mass destruction.

No Blood for Oil
(Opposite)
Los Angeles rally against 1991 gulf war

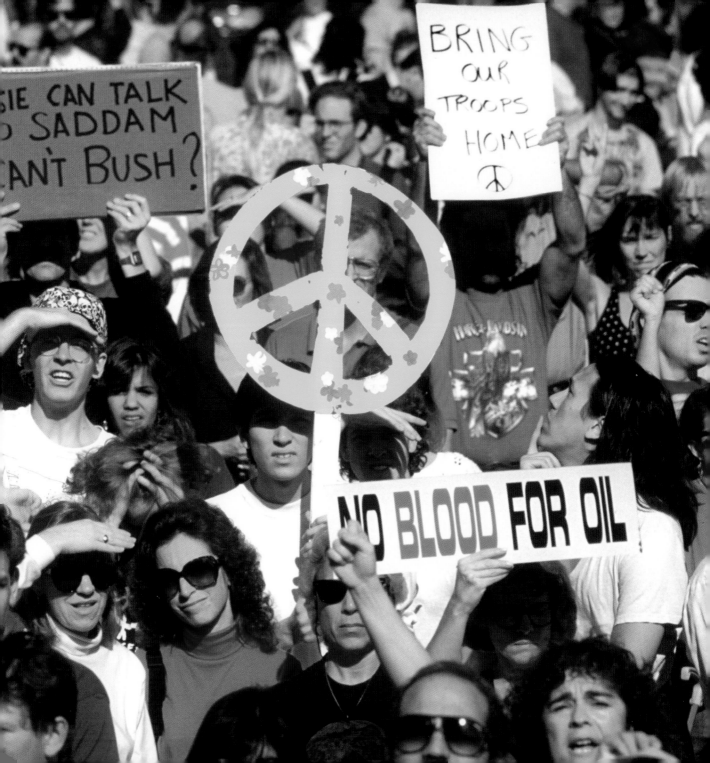

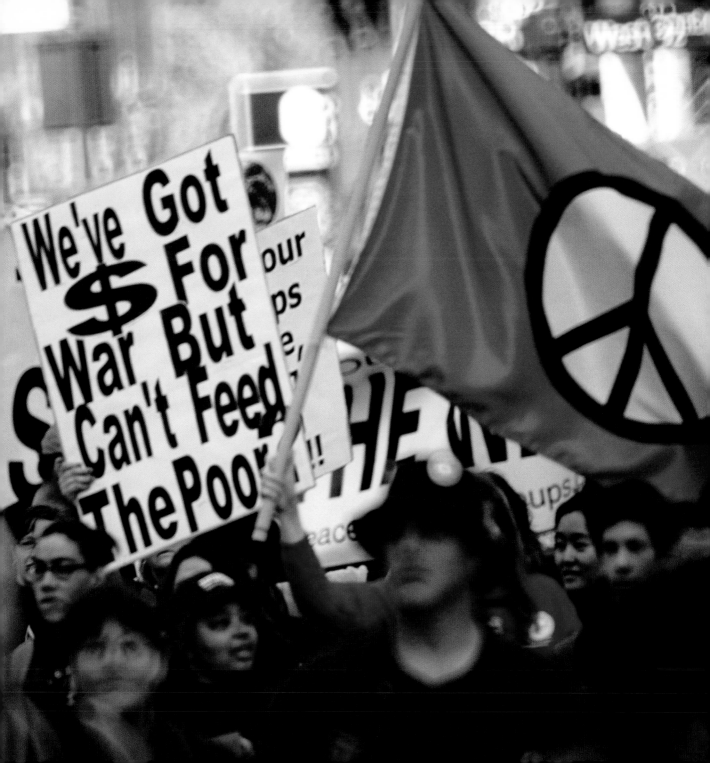

"It's a different situation," historian and antiwar activist Howard Zinn said after the opening raids on Afghanistan. "The peace movement finds itself with a message of peace in a situation where people's emotions have been aroused . . . in a way they have never been aroused before."

Aware of the belligerent public mood after terrorist-hijacked commercial planes were intentionally flown into the World Trade Center and Pentagon, antiwar advocates generally avoided confrontation and civil disobedience. "People who disagree with us say, 'We just had 6,000 casualties on our own soil. [The actual number was just under 3,000.] What do you mean, peace?' " said a 35-year-old protesting Boston doctor who wore a peace symbol on his jacket at an antiwar rally.

The peace movement has gained momentum, however, as the fighting in Afghanistan and Iraq has shifted from conventional warfare to guerrilla raids, sectarian clashes, and counterinsurgency. Several thousand American troops and many thousands of Iraqi civilians have been killed—most of them long after President George W. Bush declared an end to major combat operations on May 1, 2003.

New threats of war continue to arise around the globe and nuclear weapons remain a hot-button topic on the world stage. Yet the desire for peace, symbolized by Gerald Holtom's ubiquitous and beloved design and embraced by the millions of people who have shared its message of hope, remains as strong as ever. ☮

Iraq War Protest
(Opposite) 2003 demonstration in New York City

Cindy Sheehan
Mother of Iraq war victim protests at base in Cuba.

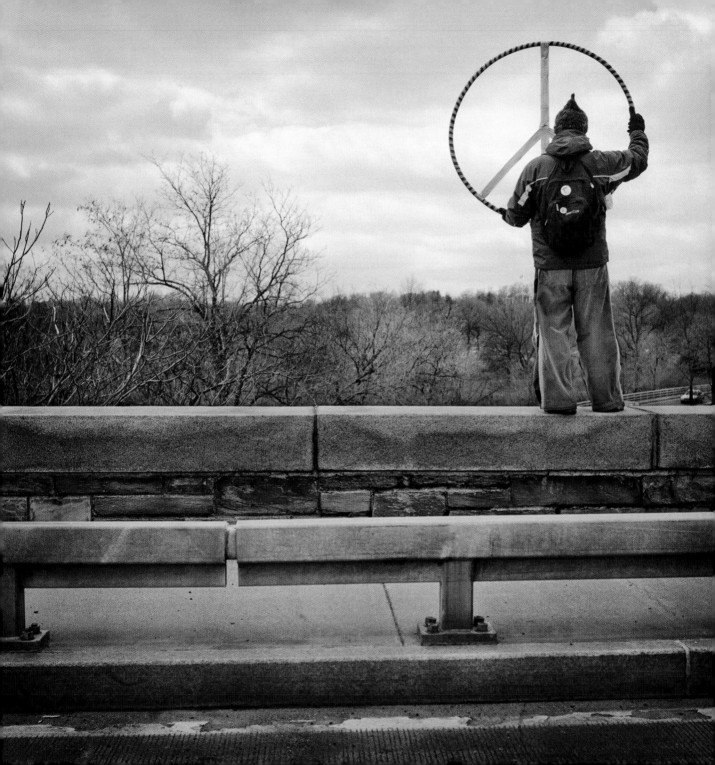

THE PEACE SYMBOL
RISES AGAIN

DEMONSTRATIONS against the war in Iraq brought the peace symbol back in style. Alice Water's Chez Panisse restaurant in Berkeley, California, distributed "peace baguettes"—bread shaped like peace symbols atop handheld poles—for antiwar demonstrators to carry in February 2003. The crowd of more than 200,000 in San Francisco greeted each other with hugs and handshakes, glad to share the message of peace on the eve of war. Also in California and other states, men and women in an unusual group known as Baring Witness stripped naked, lay on the ground, and formed giant peace symbols and short phrases such as "No War" with their bodies. They said they mirrored America's "naked aggression."

The peace symbol also appeared at antiwar protests around the world. Twenty-one women in Cape Town, South Africa, mimicked the Baring Witness protests in California by forming the word "peace" in a "21-bum salute" at the foot of Table Mountain. Demonstrators in Venezuela and Italy painted the symbol on their faces, with the vertical centerline stretching from forehead to chin and the two branches overlaying their cheeks. Filipino protesters at a peace vigil lighted candles on a huge birthday cake in Gerald Holtom's familiar design, even as American bombers hammered Iraq.

Pregnant women in Code Pink, a new antiwar group, painted the peace symbol and "Peace Womb" on their bare bellies. The group adopted its name as a spoof of the Department of Homeland Security's color-coded alert system They carried the symbol on pink placards and wore pink clothes. Members staged antiwar rallies outside the White House and in cities across the U.S. The group's signature symbolic action was delivering "pink slips"—as in pink lingerie—to public figures not fulfilling their responsibilities to the American people.

Antiwar Vigil
(Opposite) Virginia protestor marks fourth Iraq war anniversary, 2007

Belly-up for Peace
(Following pages) Youths demonstrate at U.S. Embassy in Paris, 2003.

FLASHBACK: 2000

- Bush-Gore presidential elections are decided by the Supreme Court.
- Y2K bug, expected to bite January 1, 2000, fails to materialize; predicted computer-related disasters averted.

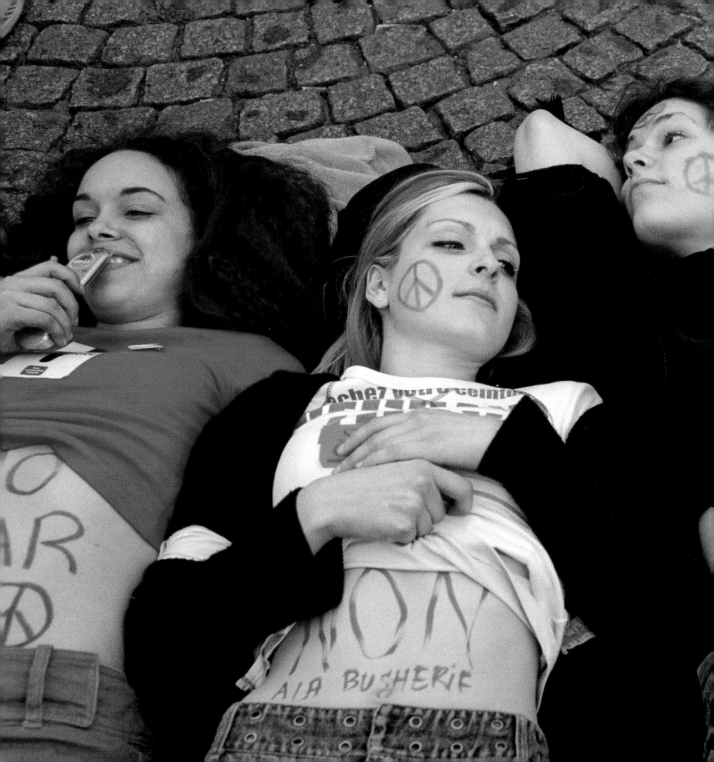

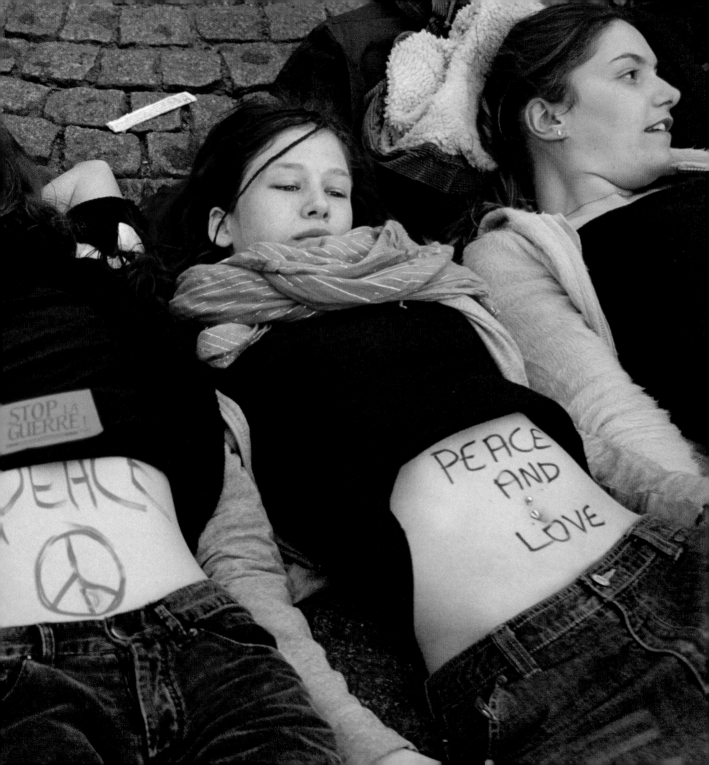

Activists also painted peace symbols on the American flag. Although these peace graffiti sparked controversy, they fell within First Amendment boundaries protected by the Supreme Court in a 1989 decision allowing flag burning as a form of speech. A University of Utah doctoral student won a showdown with two police officers after she painted a black peace symbol on the Stars and Stripes and hung it from her front door in protest of the invasion of Iraq. The officers told the student, Beth Fratkin, she faced possible prosecution under the state's "abuse of a flag" law if she didn't take it down. They didn't know that Fratkin had expert knowledge of the First Amendment. "I teach a class in free expression. I have a responsibility to my students to put my money where my mouth is, wouldn't you say?" said Fratkin. "People should not be afraid to speak out. Our democracy depends on citizen participation."

A four-foot Christmas wreath in the shape of a peace symbol led to similar controversy in Pagosa Springs, Colorado, in November 2006. Bill Trimarco and Lisa Jensen displayed the wreath on the front of their home. A homeowners association wrote the couple a letter that said, "This board will not allow any signs, flags, etc. that can be considered divisive." One association member told a newspaper he thought the symbol perhaps was linked to the devil. The group threatened Trimarco and Jensen with fines of $25 a day if they didn't remove the wreath. Instead, after a flurry of emails, phone calls, and Web blog postings by irate citizens, the association's three-member board resigned and the wreath stayed up.

Footprints in Sand
(Opposite) Hikers make symbol in New Mexico, 2005.

In triumph, supporters of Trimarco and Jensen stomped a 300-foot peace symbol in the Colorado snow. Jensen claimed the wreath was not intended as a political statement on the war in Iraq. Speaking for many who had worked for peace at some point during the previous five decades, she said, "We consider it [peace] a much broader issue. More like a way of life." ☮

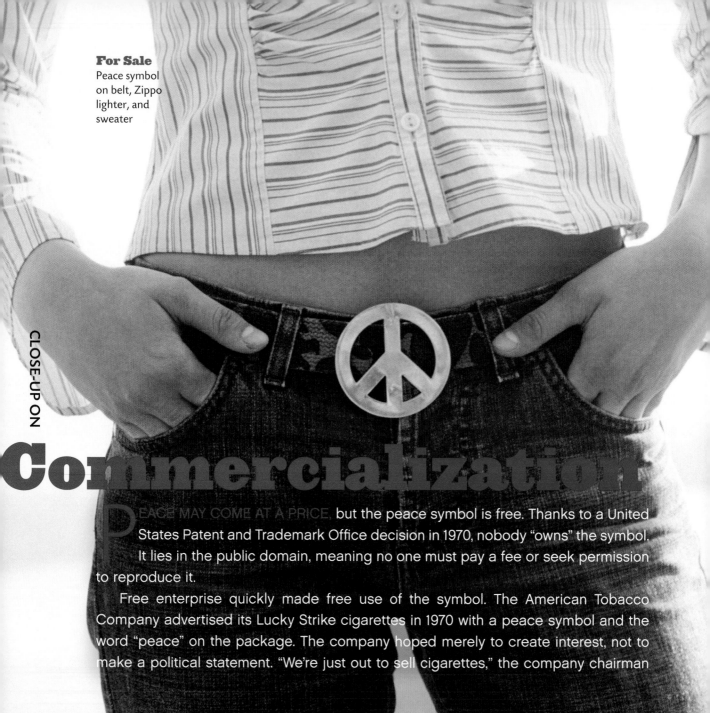

For Sale
Peace symbol on belt, Zippo lighter, and sweater

Commercialization

PEACE MAY COME AT A PRICE, but the peace symbol is free. Thanks to a United States Patent and Trademark Office decision in 1970, nobody "owns" the symbol. It lies in the public domain, meaning no one must pay a fee or seek permission to reproduce it.

Free enterprise quickly made free use of the symbol. The American Tobacco Company advertised its Lucky Strike cigarettes in 1970 with a peace symbol and the word "peace" on the package. The company hoped merely to create interest, not to make a political statement. "We're just out to sell cigarettes," the company chairman

said. Zippo, a manufacturer of cigarette lighters, followed suit by producing a lighter with the symbol embossed on its metal case.

Much of the commercialization of the symbol has been light-hearted. The Japanese automaker Subaru poked fun in 1992 with a cartoon advertisement depicting a driver getting ready to make a hood ornament out of a peace symbol, which resembles a Mer-cedes-Benz logo. The caption read, "Weld a peace sign to the hood and make believe you're driving a Mercedes that gets really great gas mileage."

Other uses have ranged from serious to quirky.

* The U.S. Postal Service gave the symbol an official stamp of approval in 1999, after a public vote selected it as one of 15 commemoratives saluting the 1960s. It was featured on a 33-cent stamp.

* Gay rights advocates market a rainbow-hued version of the symbol on T-shirts and pins.

* Feminists sell T-shirts that combine the peace symbol and the Venus sign of the biological female, as well as "NOW" buttons with the symbol filling the center letter.

* Buttons marketed toward African Americans super-impose a yellow peace symbol over a Kwanzaa back-ground of red, black, and green.

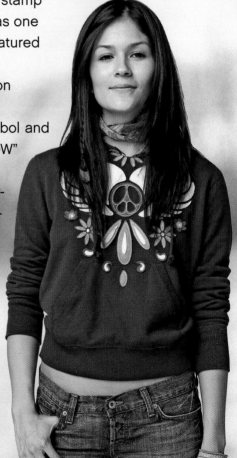

Today, countless vendors sell versions of the sym-bol in a variety of colors and modifications on can-dles, jewelry, posters, clothes, and knickknacks. In its classic black-on-white design and its many iterations, the symbol that Gerald Holtom created in 1958 is still going strong. ☮

The symbol is . . .

Gerald Holtom's peace symbol design attained worldwide recognition in just a few short years. Now, 50 years later, it's an enduring cultural icon. "Carl Jung wrote of cultural symbols as representing 'eternal truths' with archaic roots . . . which could still retain something of their original power or 'spell' in the modern world. The manner in which the nuclear disarmament sign came **a sign of engagement,** into being and acquired universal significance as a symbol of peace and protest would seem to support this thesis," wrote Andrew Rigby, Director of the Centre for the Study of Forgiveness and Reconciliation at England's Coventry University. ☮ Since its creation, the peace symbol has stood for much more than a static idea of peace. Peace is an active process rather than a singular condition or specific goal; it is a means as well as an end. As the distinguished American pacifist A. J. Muste observed, "There is no way to peace, peace is the way." Over the years, the peace symbol has represented not just a vision but also a **a declaration** path. At first it reflected a grand philosophy, but it soon expanded to signify a unified belief in a peaceful world, a movement in which everyone could participate. It became a badge of action for those, as author Robert Cooney describes them, "who refuse to violently react but who also refuse to surrender. It identifies people who are trying to 'make peace'. . . .Every country needs a vital citizenry—and a common symbol—that places peace as an overriding human demand." ☮ Even as the world becomes more complicated, as armaments become more technologically sophisticated, much of humankind is being stripped of resources for basic essentials— many are struggling to afford health care, decent educations, and a safe place to live and raise

their families. President Dwight D. Eisenhower expressed extraordinary vision when he said, "Every gun that is made, every warship launched, every rocket fired, signifies in a final sense a theft from those **of independence,** who are hungry and are not fed, those who are cold and not clothed." In his farewell address to the American people in 1961, he also issued this now famous warning, "We must guard against the acquisition of unwarranted influence, whether sought or unsought, by the military-industrial complex. The potential for the disastrous rise of misplaced power exists and will persist." ☮ For the past 50 years, millions of humans worldwide, regardless of their race or religious beliefs, have looked to the peace symbol to unite them. And the symbol's appeal continues with each succeeding generation. Children of today easily identify with

a badge of hope.

it. They may not know its original meaning, but they know it stands for good things—be nice to friends, be kind to animals, no fighting. ☮ This is a marvelous achievement for Gerald Holtom's simple design. **–Robert Cooney, Jr.** Peoples around the world have marched with it, worn it, displayed it during combat, held it high on banners, and been arrested in its name. Ask any man, woman, or child, "What one thing would everyone in the world want more than anything else?" The answer would surely be world peace. –Ken Kolsbun

Young Protest Peace marcher in San Francisco, November, 1969.

Acknowledgments

Over the past 40 years, a number of people have graciously contributed their time, information, and photographs to tell this significant story. ☮ I want to give special thanks to the Holtom family. Gerald's son Darius, daughters Rebecca and Anna, and nephew Tim Holtom have been extremely generous in sharing family photographs, Gerald's diary and notes, and their own personal comments. Their unfailing support made this a better book. ☮ Significant contributions also came from Sandy Dorbin, who helped structure my first draft in the mid-1970s, and author Robert Cooney, who gave me inspiration and guidance. I would like to acknowledge as well Pat Arrowsmith for her years of dedication to the peace movement and Wendy Chmielewski, curator of the Swarthmore Peace Collection. Special tributes go to the late Ted Schoenman for his philosophical ideas, the late Janice Scott, who provided key information—including the letter from Hugh Brock on p. 33—and to grandson Austen Pacheco, who loves photography and was there to help. ☮ My appreciation goes to my friend Marna Thompson for her broad array of talents—proofreading, writing, and editing. She was always there in a pinch. Thanks also to Jelehla Ziemba for getting the book proposal off to my agent. ☮ I will be forever grateful to my agent, Scott Mendel, who had the foresight to realize the book's potential and the importance of this story. ☮ My wife Jannice and I will be eternally thankful for our daughters, Holly, Tuesday, and Dawn, who in the late 1960s and early 70s acted as little hunters searching for peace symbols for me to photograph. ☮ This book also honors all those people who have worn Holtom's peace symbol and who continue to work for peace. ☮ Finally, I would like to dedicate this book to my wife, Jannice, for her heartfelt insight, patience, and peaceful ways. Her total support of this project and years of typing have been amazing. She has been the glue. The world would be a much better place if there were more like her.

—Ken Kolsbun, www.peacesymbol.com

Illustrations Credits

1, Bettmann/CORBIS; 2-3, Bettmann/CORBIS; 4-5, Zsolt Szigetvary/epa/CORBIS; 6-7, Marco Di Lauro/Getty Images; 8-9, Chip East/Reuters; 10-11, Richard T. Nowitz/CORBIS; 12-13, Joseph Sohm/Visions of America/CORBIS; 14, Ken Kolsbun; 18, Express Newspapers/Getty Images; 22, AP Photo/ja/Yuichiro Sasaki/UN; 23, Central Press/Getty Images; 24, AP/Wide World Photos; 25, Bettmann/CORBIS; 26, Bettmann/CORBIS; 27, AP/Wide World Photos; 28, Hulton-Deutsch Collection/CORBIS; 30-1, Time Life Pictures/National Archives/Time Life Pictures/Getty Images; 31, CORBIS; 33, Commonweal Collection/University of Bradford; 34, Courtesy Holtom Family; 36, Courtesy of Holtom Family; 37, Keystone/Getty Images; 38-9, Al Fenn/Time Life Pictures/Getty Images; 40, George Stroud/Express/Getty Images; 42-3, Larry Burrows Collection; 45, London Times; 46, Courtesy Ken Kolsbun; 47, Terry Cryer/CORBIS; 48, Sovfoto; 50, Courtesy Holtom Family; 51, Courtesy of Holtom Family; 52, Courtesy of Holtom Family; 53, Courtesy of Rebecca Holtom; 54, Courtesy Everett Collection; 58, Courtesy Robert Cooney, Jr.; 59, Bettmann/CORBIS; 60, AP/Wide World Photos; 62-3, AP/Wide World Photos; 64, Ken Kolsbun; 65, Button, Pin, and Ribbon Collection/Swarthmore College Peace Collection; 66-7, Ken Kolsbun; 68, Bettmann/CORBIS; 70, National Archives and Records Administration; 71, AFP/Getty Images; 72-3, Dan Mccoy/Time Life Pictures/Getty Images; 75, Bettmann/CORBIS; 76, Bettmann/CORBIS; 79, D.J. Mathis/Courtesy Gigline & GIs for Peace Archive/Papers of David Cortright/Swarthmore College Peace Collection; 80-1, Bernie Boston; 82, Bettmann/CORBIS; 83, Julian Wasser/Time Magazine, Copyright Time, Inc./Time Life Pictures/Getty Images; 84-5, Bettmann/CORBIS; 86, Bettmann/CORBIS; 87, Hulton-Deutsch Collection/CORBIS; 89, Billy E. Barnes/North Carolina Collection, University of North Carolina Library at Chapel Hill; 90, Roy Kemp/Getty Images; 91, *The Electric Kool-Aid Acid Test* by Tom Wolfe published by Farrar Straus Giroux (1968); 92, Ken Kolsbun; 93, Ken Kolsbun; 94, TK; 95, Ted Streshinsky/CORBIS; 96-7, Ken Kolsbun; 99, AP/Wide World Photos; 100-1, Suki Hill; 101, Bill Graham Archives, LLC/www.wolfgangsvault.com; 102, Henry Diltz/CORBIS; 103, Henry Diltz/CORBIS; 104-5, Henry Diltz/CORBIS; 106, Bettmann/CORBIS; 110, © The Los Angeles Times, 1972; 111, John Filo/Getty Images; 112, Leif Skoogfors/CORBIS; 113, *Time Magazine*, November 2, 1970, vol. 96, no. 18; 114, © Peter Max 2007; 115, © Peter Max 2007; 116-7, Ken Kolsbun; 118, Bettmann/CORBIS; 119, Bettmann/CORBIS; 120-1, Wally McNamee/CORBIS; 122, Steven Clevenger/CORBIS; 123, David J. & Janet L. Frent Collection/CORBIS; 124, MPI/Getty Images; 125, Wally McNamee/CORBIS; 126-7, Bettmann/CORBIS; 127, AP Photo/Dima Gavrysh; 128, Paul Conrad/© Tribune Media Services, Inc. All rights Reserved. Reprinted with permission; 129, Bettmann/CORBIS; 130-1, Henry Diltz/CORBIS; 132-3, Ken Kolsbun; 134, Hulton Archives/Getty Images; 135, Christopher Springmann/Time Life Pictures/Getty Images; 136, Ken Kolsbun; 137, Rex Weyler; 138-9, AP/Wide World Photos; 140, Courtesy Robert Cooney, Jr.; 141, AP/Wide World Photos; 142, Owen Franken/CORBIS; 144, Rick Wilking/Reuters; 148, Steve Benson/Creators Syndicate; 149, Lowell Georgia/CORBIS; 150, Robert Maass/CORBIS; 151, Bettmann/CORBIS; 152-3, Khaled Jarrar/Apollo Images/Polaris; 155, Romeo Gacad/AFP/Getty Images; 156-7, Bettmann/CORBIS; 158, Department of Defense/Time Life Pictures/Getty Images; 161, Joseph Sohm/Visions of America/CORBIS; 162, Paul Colangelo/CORBIS; 163, Alejandro Ernesto/epa/CORBIS; 164, Jason Andrew; 166-7, Abbas/Magnum Photos; 169, Momatiuk - Eastcott/CORBIS; 170-1, Ole Graf/zefa/CORBIS; 171 (UP), Courtesy of Zippo; 171 (LO) Peggy Sirota/Courtesy Lucky Brand Jeans; 173, Ken Kolsbun.

PEACE

Ken Kolsbun with Mike Sweeney

Published by the National Geographic Society

John M. Fahey, Jr., *President and Chief Executive Officer*
Gilbert M. Grosvenor, *Chairman of the Board*
Tim T. Kelly, *President, Global Media Group*
Nina D. Hoffman, *Executive Vice President;
President, Book Publishing Group*

Prepared by the Book Division

Kevin Mulroy, *Senior Vice President and Publisher*
Leah Bendavid-Val, *Director of Photography Publishing
and Illustrations*
Marianne R. Koszorus, *Director of Design*
Barbara Brownell Grogan, *Executive Editor*
Elizabeth Newhouse, *Director of Travel Publishing*
Carl Mehler, *Director of Maps*

Staff for This Book

Lisa Thomas, *Project Editor*
Jessica Taraski, *Photo Editor*
Melissa Farris, *Art Director*
Karen Kostyal, *Text Editor*
Olivia Garnett, *Contributing Editor*
Margo Browning, *Contributing Editor*
Marshall Kiker, *Illustrations Specialist*
Al Morrow, *Design Assistant*
Michael Horenstein, *Production Manager*

Jennifer A. Thornton, *Managing Editor*
Gary Colbert, *Production Director*
Meredith C. Wilcox, *Administrative Director, Illustrations*

Manufacturing and Quality Management

Christopher A. Liedel, *Chief Financial Officer*
Phillip L. Schlosser, *Vice President*
John T. Dunn, *Technical Director*
Chris Brown, *Director*
Maryclare Tracy, *Manager*
Nicole Elliott, *Manager*

Founded in 1888, the National Geographic Society is one of the largest nonprofit scientific and educational organizations in the world. It reaches more than 285 million people worldwide each month through its official journal, NATIONAL GEOGRAPHIC, and its four other magazines; the National Geographic Channel; television documentaries; radio programs; films; books; videos and DVDs; maps; and interactive media. National Geographic has funded more than 8,000 scientific research projects and supports an education program combating geographic illiteracy.

For more information, please call 1-800-NGS LINE (647-5463)
or write to the following address:

National Geographic Society
1145 17th Street N.W.
Washington, D.C. 20036-4688 U.S.A.

Visit us online at www.nationalgeographic.com/books

For information about special discounts for bulk purchases, please contact National Geographic Books Special Sales: ngspecsales@ngs.org

For rights or permissions inquiries, please contact National Geographic Books Subsidiary Rights: ngbookrights@ngs.org

ISBN 978-1-4262-0294-0

Library of Congress Cataloging-in-Publication Data

Kolsbun, Ken.
 Peace : the biography of a symbol / by Ken Kolsbun with Mike Sweeney.
 p. cm.
 ISBN 978-1-4262-0294-0
1. Peace movements--History--20th century. 2. Peace movements--History--21st century. 3. Signs and symbols--History--20th century. 4. Signs and symbols--History--21st century. 5. Protest movements--History--20th century. 6. Protest movements--History--21st century. 7. Antinuclear movement--History. I. Sweeney, Michael S. II. Title.
JZ5574.K68 2008
303.6'6--dc22

Printed in the United States